Techniques for Drawing Female Manga Characters

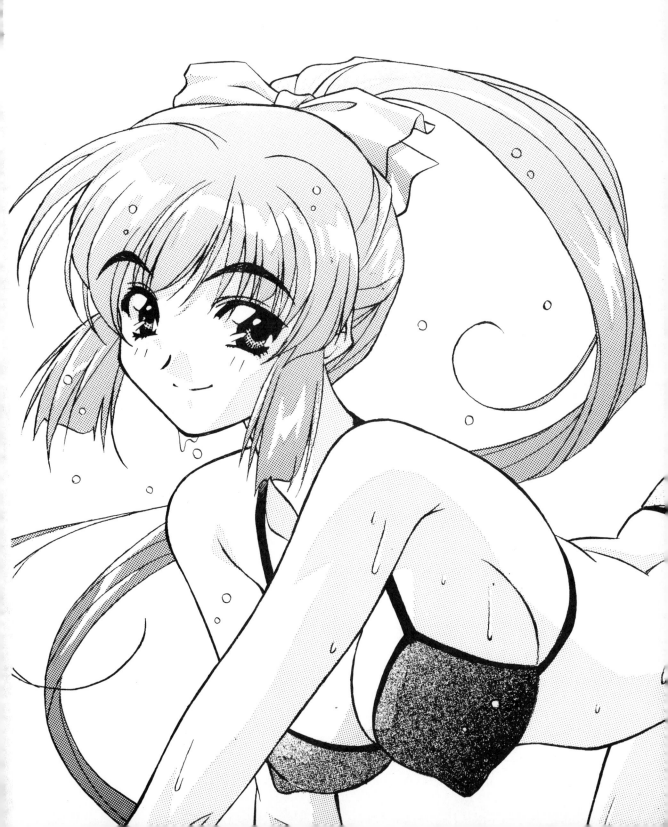

Table of Contents

Chapter 1

Drawing the Female Figure: The Basic Rules....................5
The Three Basic Rules for Drawing the Female Figu............6
The Human Body............8
Characteristics of the Female Figure10
Seeing the Body as a Wire Frame and with Contour Shadows12
Differentiating Body Types............14
Some Tips for Differentiating the Three Physical Types................16
Differences in Figure According to Age17
Differences of Face According to Age....................18
Q & A............20

Chapter 2

Drawing the Female Figure: The Parts of the Body21
True-to-Life vs. Manga:
What to Exaggerate and What to Simplify22
The Breasts............24
Effects You Can Achieve With the Breasts....................36
Bust Line Fashion Statements38
The Buttocks............40
Different Views of the Buttocks....................41
The Contour of the Buttocks....................42
Effects You Can Achieve with the Buttocks44
The Crotch............46
Using Curved Lines to Show Dimension in the Crotch46
The Lower Body in Action....................52
The Relation Between the Buttocks, Crotch, and Legs............54
The Legs............56
The Neck - Connecting the Head to the Body64
The Bent Back - When You Can't Draw a Tapered Waist............66
The Effect of Underwear and Bathing Suits on the Female Figure 68
Water Droplets and Beads of Sweat............70
Wire Frames - Getting a Grasp of the Body's Curves72
Using Wire Frames74
Q & A............76

Chapter 3

Drawing the Female Figure: Using Detail for Effect....................77
Different Types of Nails............78
Eyes, Eyelids, and Eyelashes............80

The Mouth and Lips............84
Effects You Can Achieve with Black and Shading............85
The Ears and Earrings............86
The Hair............87
Coloring the Hair............88
A Catalogue of Undergarments............90
Q & A............96
The Female Figure Goes to School............97
1. Getting Dressed: The Blouse............97
2. Getting Dressed: Shoes and Socks............98
3. Getting Dressed: In Front of the Mirror............99
4. Running Down the Hallway............100
5. Sitting on a Chair101
6. On the Playground at Noon: In Uniform102
7. In the Locker Room103
8. Dressed for Gym Class............104
9. More Tips for Drawing Gym Clothes105
10. Regulation Bathing Suits106
11. Riding a Bicycle............107
12. On the Way Home: Walking Outdoors108

Chapter 4

Learn from the Pros............109
Girl in Middy Uniform (Masaru Kaku)............110
Beauty with Bouquet(Jun Matsubara)112
Alluring Adult (Yasuo Matsumoto)114
Dream Fantasy (Morio Harada)116
Girl Athlete (Bancho Hoshino)118
Sexy Babe (Ganma Suzuki)120
Humorous Illustration (Shoko Ando)122
Coquettish Maiden (Yu Manabe)124
Glamourous Beauty (Noriyoshi Inoue)126

HOW TO DRAW MANGA: Female Characters
by Hikaru Hayashi, Go Office

First designed and published in 1998 by Graphic-sha Publishing Co., Ltd.
This English edition was published in 1999 by Graphic-sha Publishing Co., Ltd.
1-14-17 Kudan-kita, Chiyoda-ku, Tokyo 102-0073, Japan

Production managers: Yasuo Matusmoto, Jun Matsubara, Bancho Hoshino
Original cover picture: Ganma Suzuki
Reference work / Collaborators: Yasuo Matsumoto, Jun Matsubara,
 Bancho Hoshino, Masaru Kaku,
 Ganma Suzuki, Morio Harada, Yu Manabe,
 Shoko Ando and special thanks for
 Noriyoshi Inoue

Composition / Scenario: Hikaru Hayashi, Go Office
Cover design and text layout: Hideyuki Amemura
English translation: Língua fránca, Inc.
Editor: Motofumi Nakanishi (Graphic-sha Publishing Co., Ltd.)
Foreign language edn. project coordinator: Kumiko Sakamoto (Graphic-sha Publishing Co., Ltd.)

First printing: December 1999
Second printing: June 2000
Third printing: March 2001
Fourth printing: May 2001
Fifth printing: August 2001
Sixth printing: November 2001
Seventh printing: March 2002
Eighth printing: November 2002
Ninth printing: February 2003
Tenth printing: June 2003
Eleventh printing: September 2003
Twelfth printing: January 2004
Thirteenth printing: May 2004
Fourteenth printing: July 2004
Fifteenth printing: November 2004
Sixteenth printing: May 2005

ISBN4-7661-1146-X
Printed and bound in China by Everbest Printing Co., Ltd.

Drawing the Female Figure:
The Basic Rules

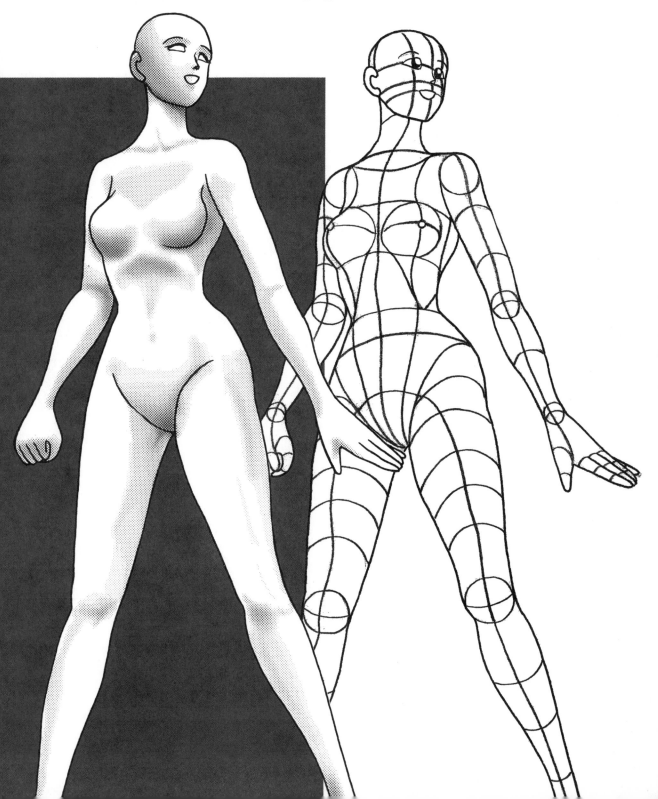

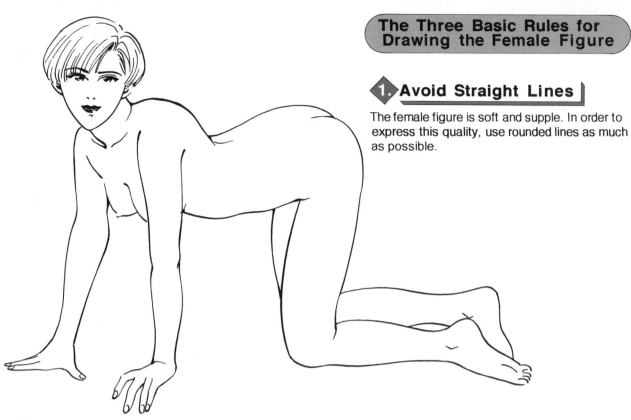

1. Avoid Straight Lines

The female figure is soft and supple. In order to express this quality, use rounded lines as much as possible.

2. Envision a Triangle

The female figure characteristically has a larger pelvis than the male figure. The hips should be drawn wide.

When blocking out your drawing, it's helpful to think of a triangle whose base is the width of the pelvis and whose apex is the top of the head.

Shoulder and Hip Width of the Male Figure

When drawing the male figure, the shoulders should be wider than the hips.

Even when a man has narrow shoulders, the hips should be drawn narrower than the shoulders.

When drawing a woman with broad shoulders . . .

A woman with wide shoulders becomes more feminine if drawn with her hip sticking out.

3. Envision a Figure Eight

The secret to drawing a shapely female figure is to give her a slender waist and broad hips. In essence, you want to think of a figure 8.

First draw the head.

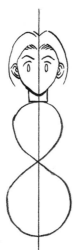

1. It helps to draw a guide line down the center.

2. Draw a figure 8 for the body under the head.

3. Draw small circles where the arms and legs will be attached. These will become the joints.

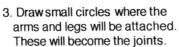

4. Flesh out the waist and draw the arms and legs.

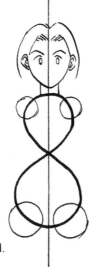

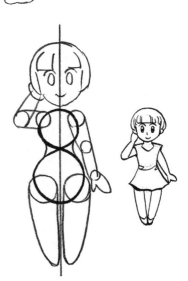

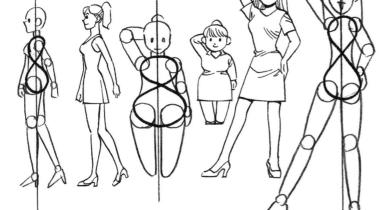

- You can vary the body type by drawing a tall and slender 8 or short and squat 8.
- The size of the circles drawn for the joints determines the thickness of the arms and legs.

The Human Body

The flesh is essentially clothing for the bones. Ask "What kind of clothes do I want these bones to wear?" You can create an endless variety of figures by changing how you "dress" the bones with flesh.

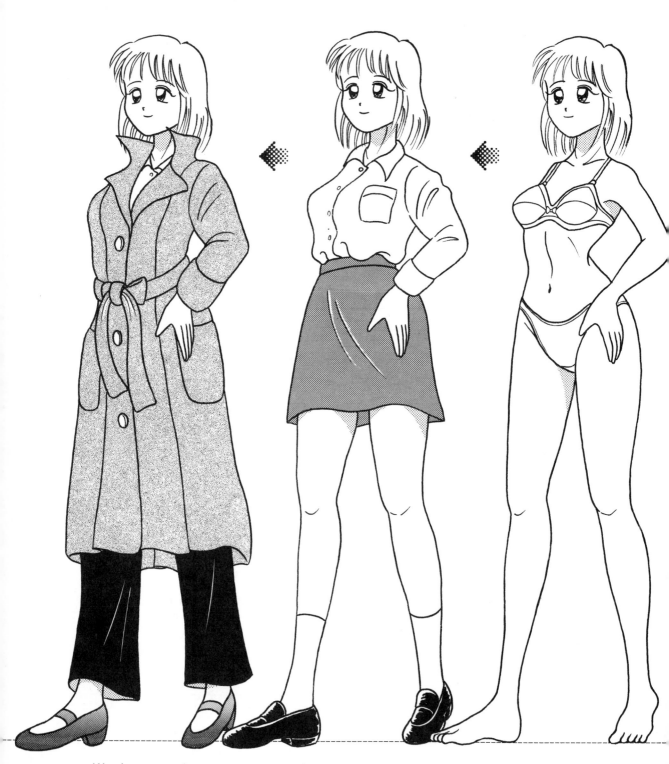

Wearing overcoat In skirt and blouse In undergarments

The human body is built upon a skeleton of bones, which are covered with muscle, fat, and skin. Bone structure and the flesh (muscle and fat) attached to it vary from person to person.

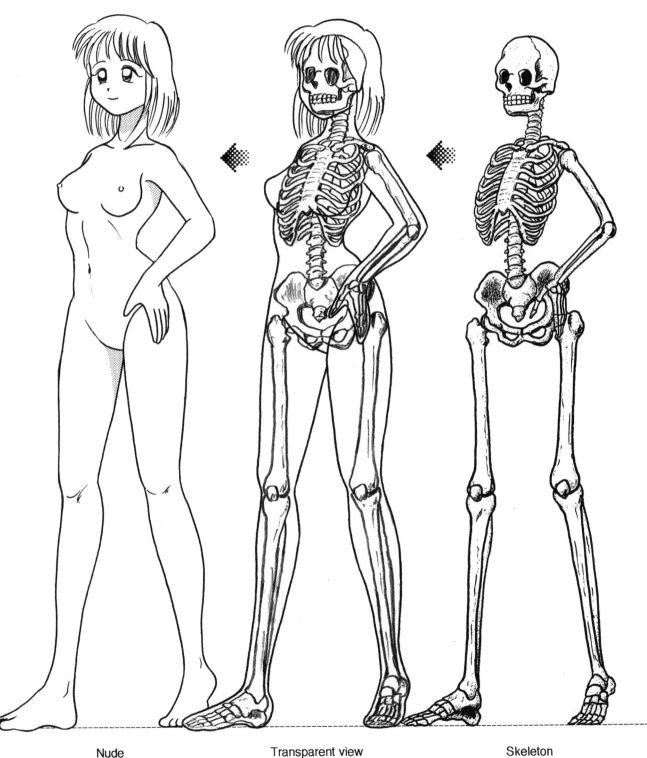

Nude Transparent view Skeleton

Characteristics of the Female Figure

The female figure is defined most prominently by the bust, the waist, and the hips.

Neck: A thick neck makes the figure look like a small child; for a grown woman, draw a long, slender neck.

Collarbone

Breasts: Shape, size, position, and preferences among breasts are as varied as their owners. See page 22.

Ribs: A lightly-drawn rib line gives the stomach and torso a trim look (but be careful: if the line is too heavy, it creates a gaunt look).

Hips: From the front, the widest part of the hips are determined by the bones.

Crotch: There is always a space between the thighs at the crotch even when standing with knees together.

10

The shoulder, upper arm, and armpit are crucial in showing maturity.

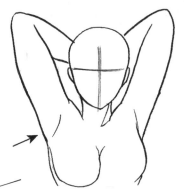

Immature figure: Even when the arms are lifted, a single line is adequate for showing the armpit.

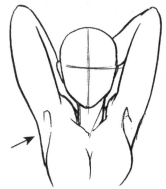

Mature figure: The armpit must be drawn to show three-dimensional contours.

A child's shoulders are simply rounded.

The tapering of the ribs

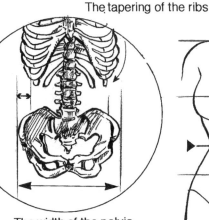

The width of the pelvis

The difference between the tapering of the ribs and the width of the pelvis determines the size of the waist.

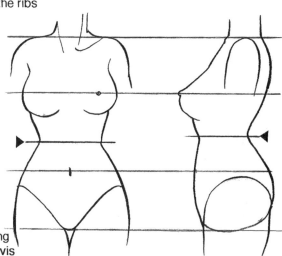

Note that the position of the waist is slightly different when viewed from the front and the side.

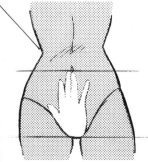

he line leading down to the navel xpresses the subtle curves of he stomach and lower abdomen.

From the navel down to the crotch should appear as a gently rounded curve. You can achieve this impression from the front by applying screentones.

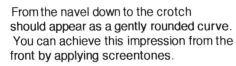

The position of the navel should be a little below the waste and one hand up from the crotch.

The curve of the crotch can be either flat or mounded.

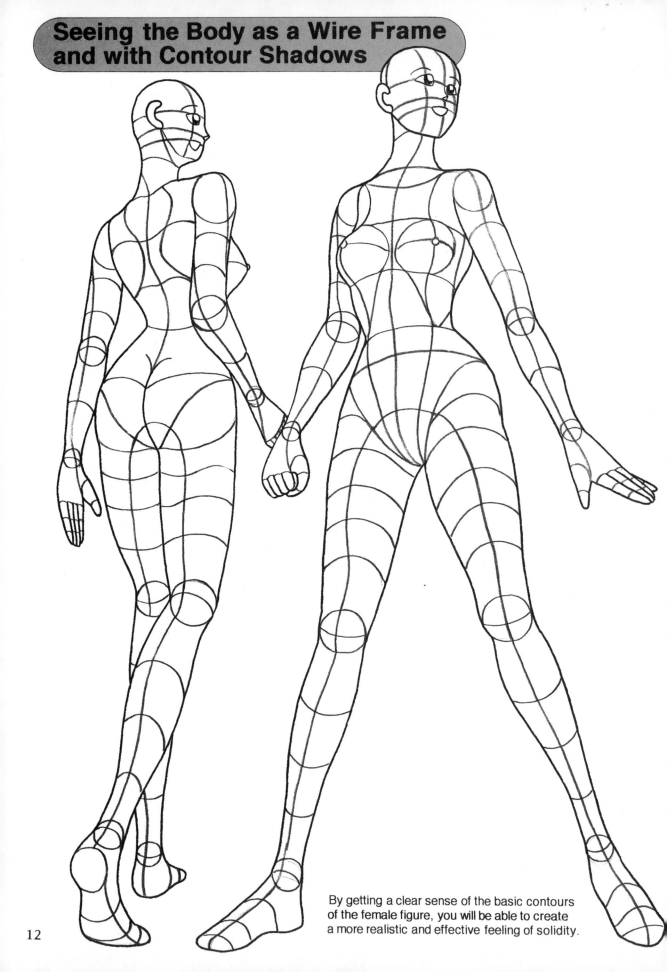

Seeing the Body as a Wire Frame and with Contour Shadows

By getting a clear sense of the basic contours of the female figure, you will be able to create a more realistic and effective feeling of solidity.

12

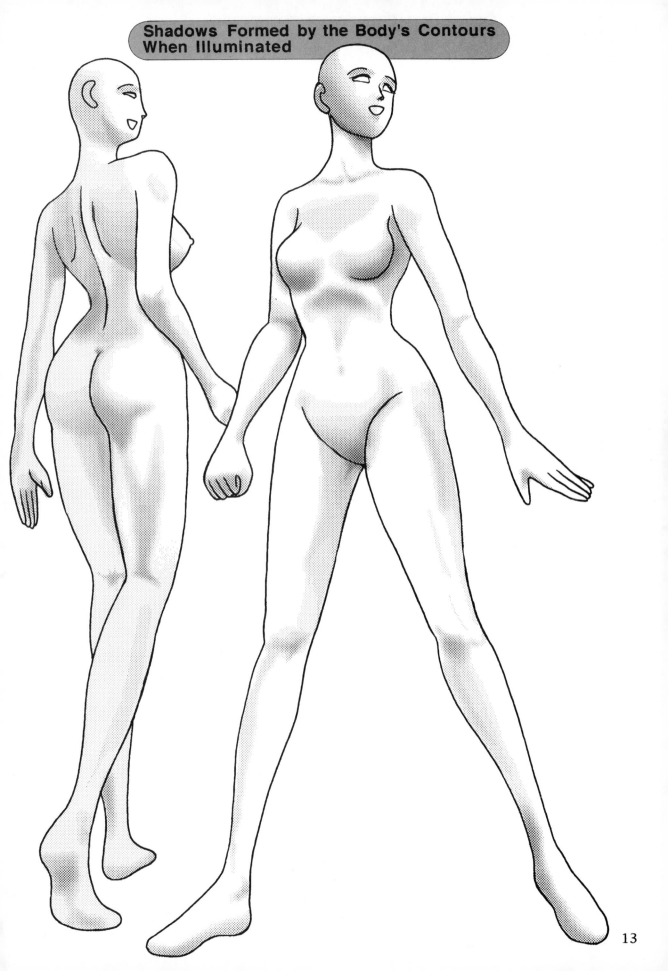

Shadows Formed by the Body's Contours When Illuminated

13

Differentiating Body Types

If you understand how the differences in bone structure and body type affect their proportions, you'll be able to draw a wide variety of female figures.

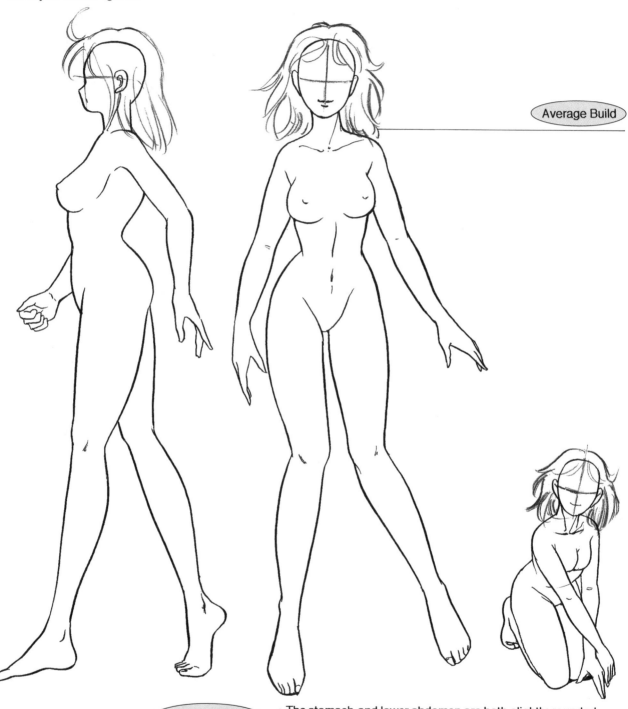

Average Build

The Average Figure

- The stomach and lower abdomen are both slightly rounded.
- The chest and body as a whole are curvaceous, and the torso is quite short.
- The shoulders, arms, and legs are all somewhat fleshy; even when the legs and arms are long, they have a fullness to them.
- The sides of the chest and hips form a shapely curve.
- The hips are broad.

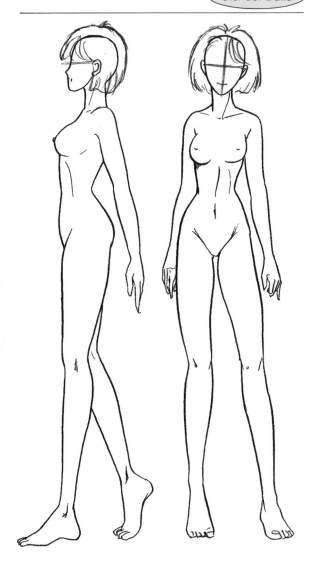

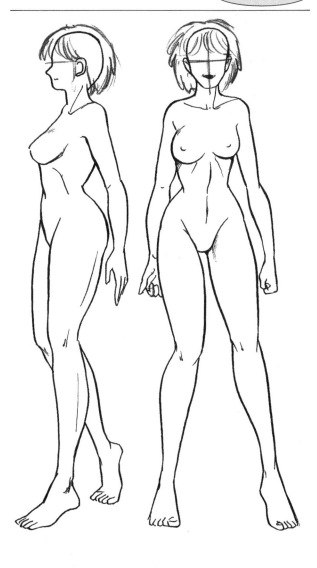

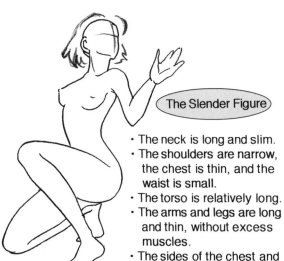

The Slender Figure

· The neck is long and slim.
· The shoulders are narrow, the chest is thin, and the waist is small.
· The torso is relatively long.
· The arms and legs are long and thin, without excess muscles.
· The sides of the chest and hips form a much gentler curve.

The Athletic Figure

· A prominent breastbone
· Broad shoulders to house well-developed lungs.
· Limbs are drawn more tapered at the elbows and knees, wrists and ankles (but be careful not to overdo it, or you will create a beefy look).
· Although the thighs are thick, the muscles taper at the knee creating the sharpest curve.

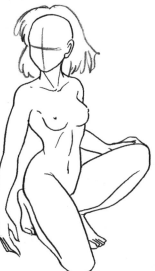

The key points to note are:

1. The curve from the back to the hips
2. The line from the shoulder down the arm
3. The rib line below the breast
4. The thickness of the thighs

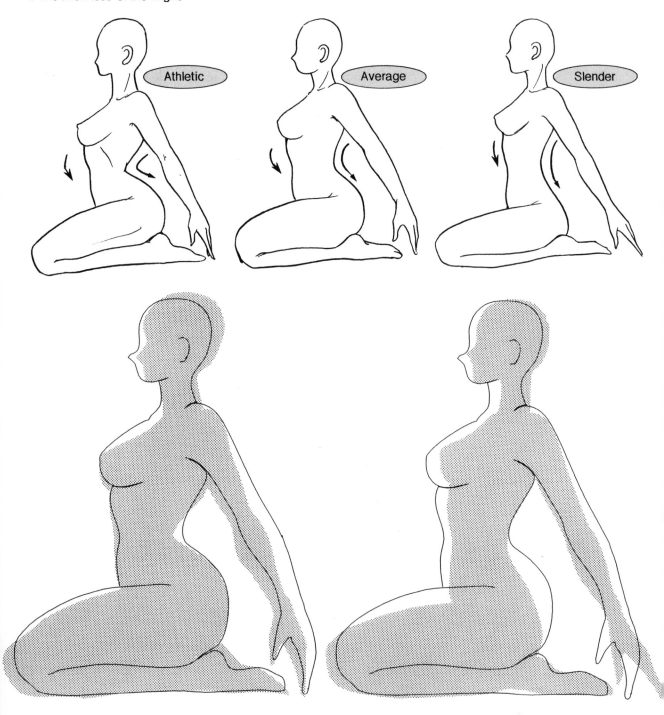

An athletic figure superimposed on an average figure.

A slender figure superimposed on an average figure.

Differences in Figure According to Age

Finger length represents one of the most prominent differences between the figures of adult and child. Also, for adolescent girls you can create a youthful appearance by drawing the body of an adult, but with more rounded lines overall.

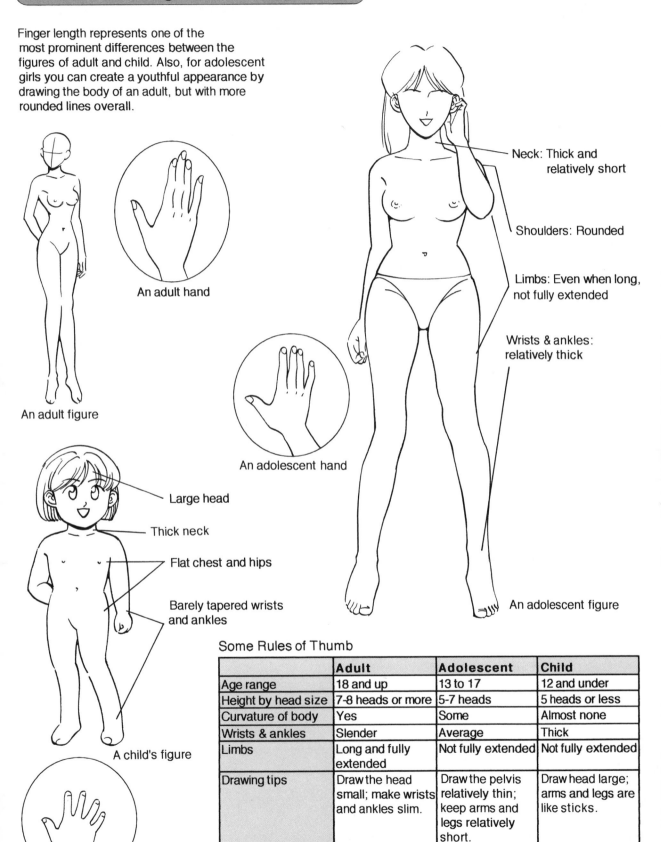

An adult hand

An adult figure

An adolescent hand

Neck: Thick and relatively short

Shoulders: Rounded

Limbs: Even when long, not fully extended

Wrists & ankles: relatively thick

An adolescent figure

Large head

Thick neck

Flat chest and hips

Barely tapered wrists and ankles

A child's figure

A child's hand

Some Rules of Thumb

	Adult	Adolescent	Child
Age range	18 and up	13 to 17	12 and under
Height by head size	7-8 heads or more	5-7 heads	5 heads or less
Curvature of body	Yes	Some	Almost none
Wrists & ankles	Slender	Average	Thick
Limbs	Long and fully extended	Not fully extended	Not fully extended
Drawing tips	Draw the head small; make wrists and ankles slim.	Draw the pelvis relatively thin; keep arms and legs relatively short.	Draw head large; arms and legs are like sticks.

Note: Women in the 18 to 19-year-old range will have elements of both the adult and adolescent figure.

Differences of Face According to Age

To differentiate the faces of adults and children, pay attention to these two elements:

1. The distance between the eyes and the mouth
2. The bridge of the nose

Profiles in manga-style drawings

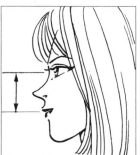

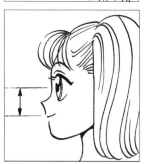

Profiles in illustrator-style drawings

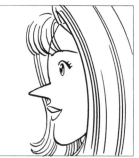

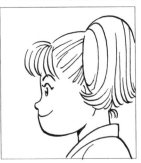

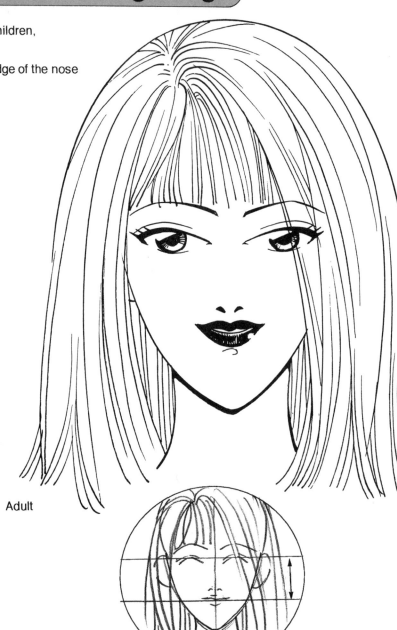

Adult

Some Rules of Thumb

	Adult Features	Child Features
Distance between eyes and mouth	Far apart	Close together
Shape of face	Slightly longer	Round
Eyes	Small	Large
Bridge of nose	Draw clearly	Don't emphasize
Neck	Slender and long	Thick
Head	Small	Large

Child

The Bridge of the Nose From an Angle

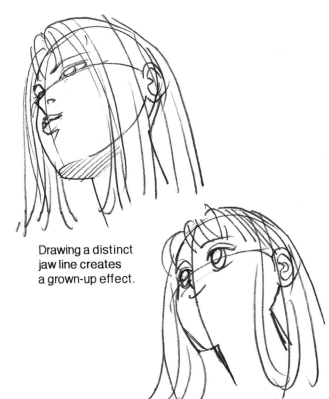

Drawing a distinct
jaw line creates
a grown-up effect.

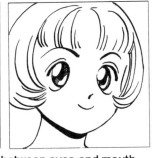

By adjusting the distance between eyes and mouth,
you can differentiate between an adult and a child
with or without the bridge line drawn in.

Q&A

What if you want to draw an older woman with a round face, or a child with a slightly longer face and pointy chin?

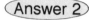
Answer 1

A grown woman with a round face

1. Keep the eyes small.
2. Maintain distance between eyes and mouth.

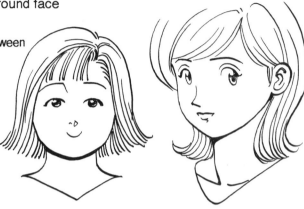

Answer 2

A child with a grown-up face.

· For a somewhat baby-faced look, make the eyes larger.

· Round faces tend to look too large, so it helps to reduce the amount of hair.

1. Draw large eyes.
2. Tighten the distance between eyes and mouth.
3. Minimize the nose.
4. Make the head larger by giving more volume to the hair.

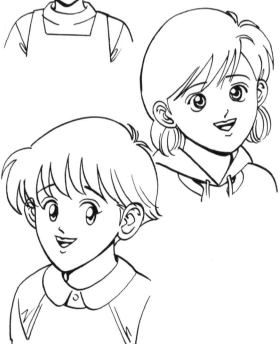

· Smaller eyes always make the face look more grown-up.
· It also helps to draw large ears and make the neck short and thick.

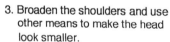

A Grown Woman with a Round Face

In order to make a woman with a round face, large eyes, and big hair look more grown-up:

1. Give her a long neck, and draw in the collarbone.
2. Draw her figure to adult proportions.

3. Broaden the shoulders and use other means to make the head look smaller.

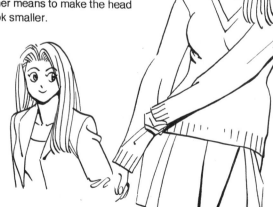

Chapter 2

Drawing the Female Figure: The Parts of the Body

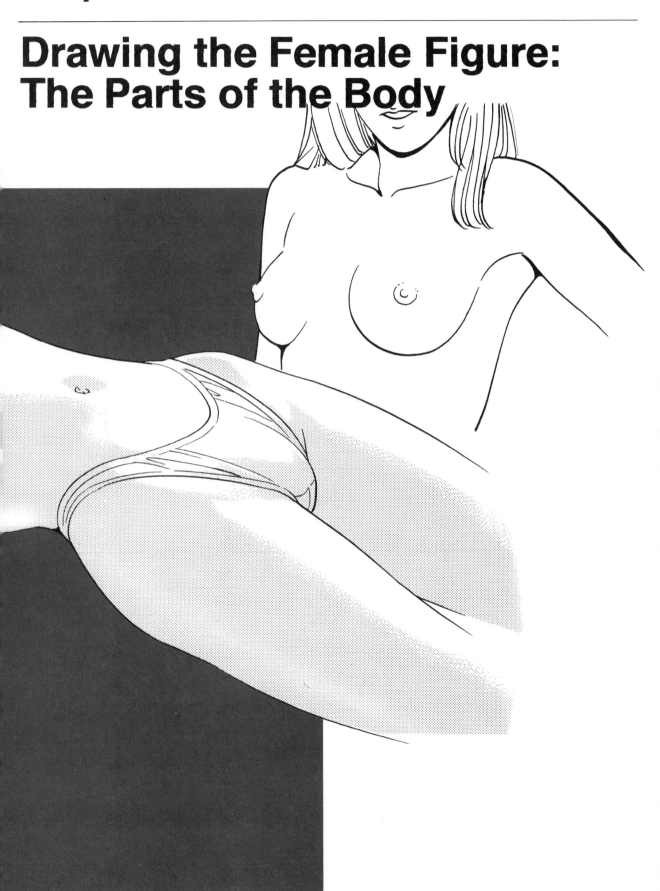

True-to-Life vs. Manga

What to Exaggerate and What to Simplify

When using a photograph or other model for your drawing, exaggerate or simplify various aspects of the model to create a figure that suits your own taste.

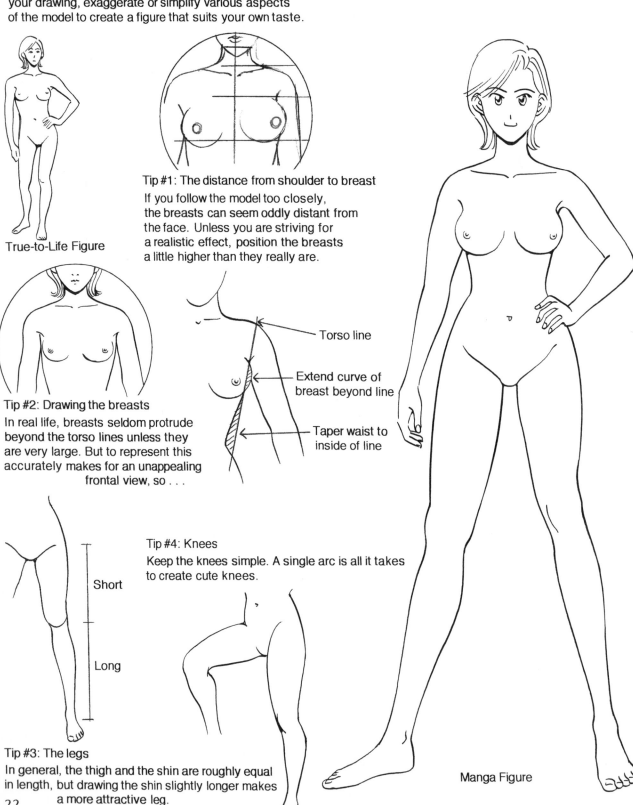

True-to-Life Figure

Tip #1: The distance from shoulder to breast

If you follow the model too closely, the breasts can seem oddly distant from the face. Unless you are striving for a realistic effect, position the breasts a little higher than they really are.

Tip #2: Drawing the breasts

In real life, breasts seldom protrude beyond the torso lines unless they are very large. But to represent this accurately makes for an unappealing frontal view, so . . .

Torso line

Extend curve of breast beyond line

Taper waist to inside of line

Tip #4: Knees

Keep the knees simple. A single arc is all it takes to create cute knees.

Short

Long

Tip #3: The legs

In general, the thigh and the shin are roughly equal in length, but drawing the shin slightly longer makes a more attractive leg.

Manga Figure

22

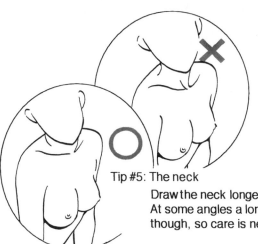

The contour of the back includes many bumps and dips, but normally only the following need be drawn:
1. Lines for the spine and shoulder blades
2. The buttocks

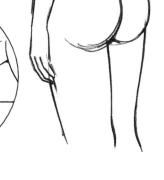

Tip #5: The neck

Draw the neck longer and slimmer than the model. At some angles a longer neck may look odd, though, so care is needed.

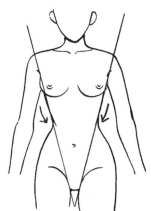

Tip #6: Taper the waist sharply

The angle from armpit to waist will often leave the figure waistless if drawn realistically, so it almost always calls for exaggeration. Follow imaginary lines drawn from the armpits to the crotch.

Back Tip #1: Creases

Many creases tend to form around the neck and shoulder blades as well as at the waist, but you should omit most of them for a prettier back.

Tip #7: The position of the waist

For the cutest look place the waist about one breast-height below the breasts. A more realistic distance is about one head below the breasts.

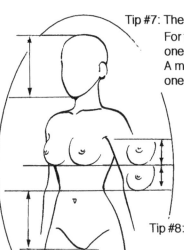

Tip #8: The distance from waist to crotch

The waist and crotch are normally about one head apart. If this distance is too short, the hips/pelvis will look too slight and the figure unbalanced.

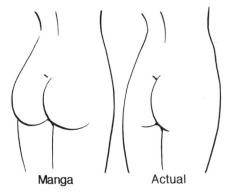

Manga Actual

Back Tip #2: The buttocks

A simple standing pose cannot fully illustrate manga-style buttocks. See page 38.

The Breasts

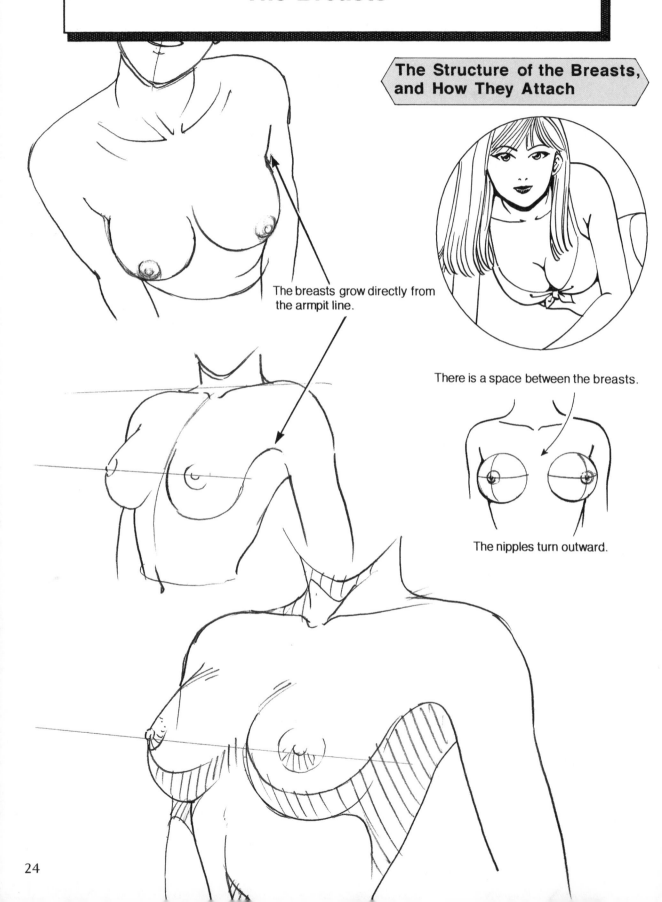

The breasts grow directly from the armpit line.

There is a space between the breasts.

The nipples turn outward.

24

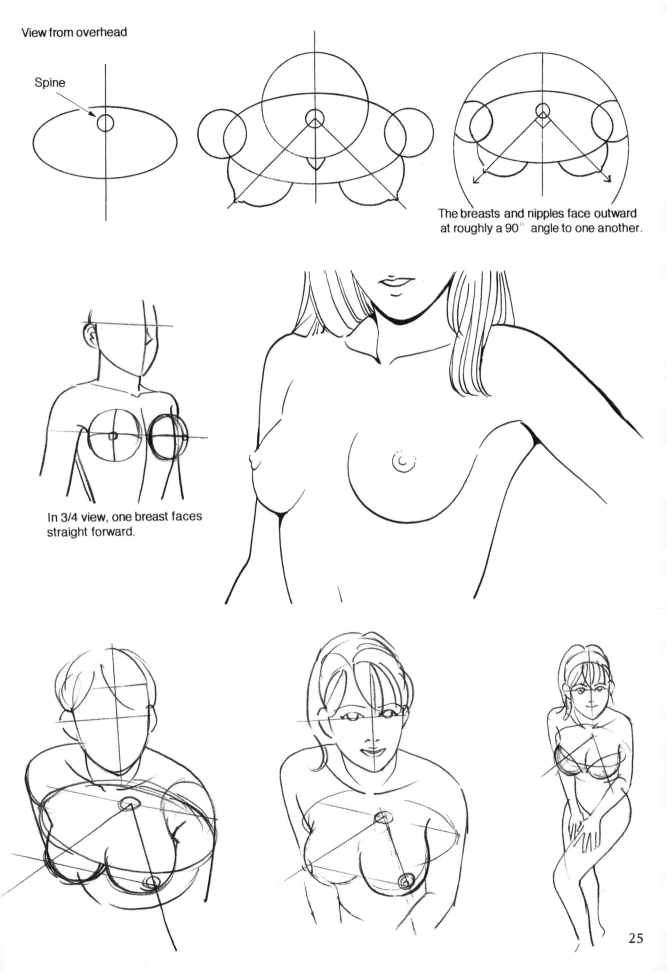

View from overhead

Spine

The breasts and nipples face outward at roughly a 90° angle to one another.

In 3/4 view, one breast faces straight forward.

25

Because breasts are soft and pliable, you can achieve very different effects by how you dress the figure.

Bound tight with muslin

Enhanced

Clothing that accentuates size and shape

Bra-less

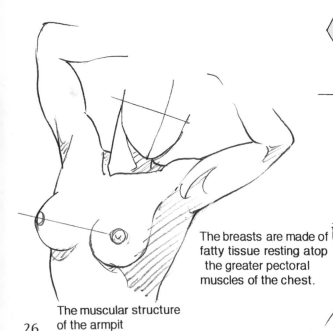

The muscular structure of the armpit

The breasts are made of fatty tissue resting atop the greater pectoral muscles of the chest.

The Rib Cage and the Breasts

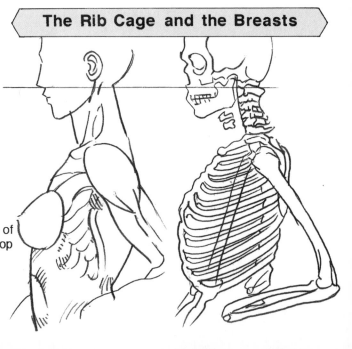

26

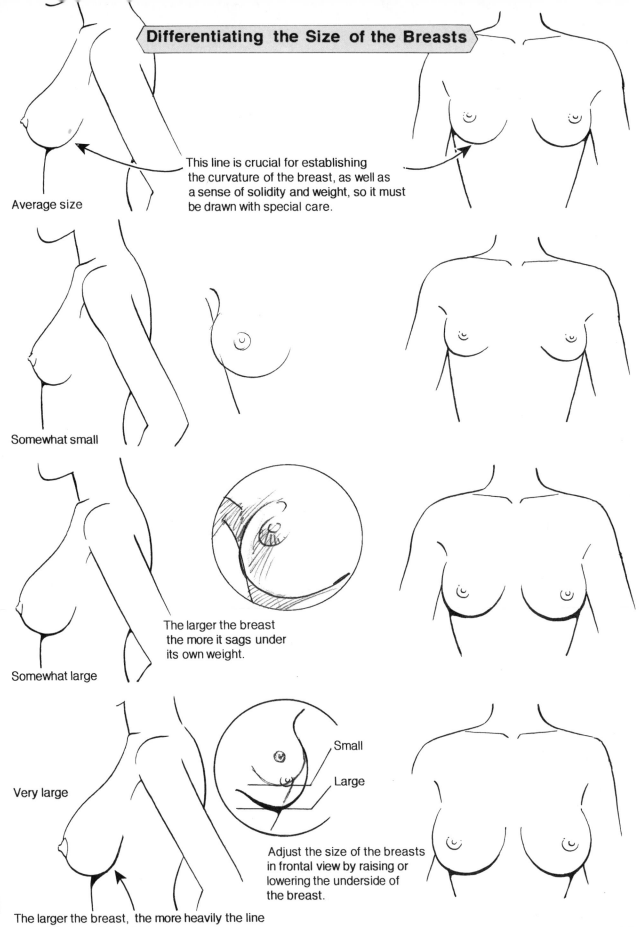

Differentiating the Size of the Breasts

This line is crucial for establishing the curvature of the breast, as well as a sense of solidity and weight, so it must be drawn with special care.

Average size

Somewhat small

The larger the breast the more it sags under its own weight.

Somewhat large

Very large

Small

Large

Adjust the size of the breasts in frontal view by raising or lowering the underside of the breast.

The larger the breast, the more heavily the line under the breast should be drawn.

Breasts of Different Shapes

In general, breasts fall into three basic shapes, but countless variations are possible among them.

Cup

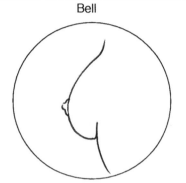

Bell

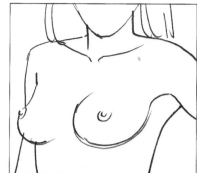

Bowl

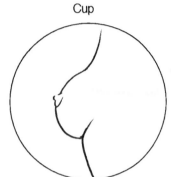

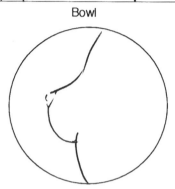

The Posision of the Breasts

The impression created varies greatly by how the breasts are positioned.

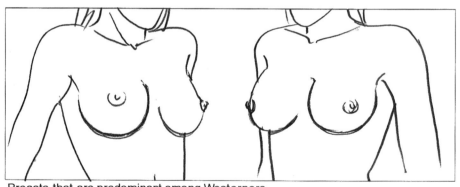

Breasts that are predominant among Westerners

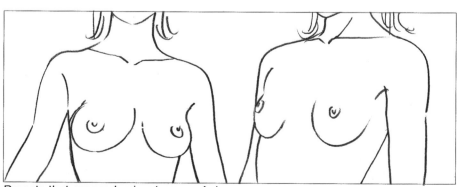

Breasts that are predominant among Asians

28

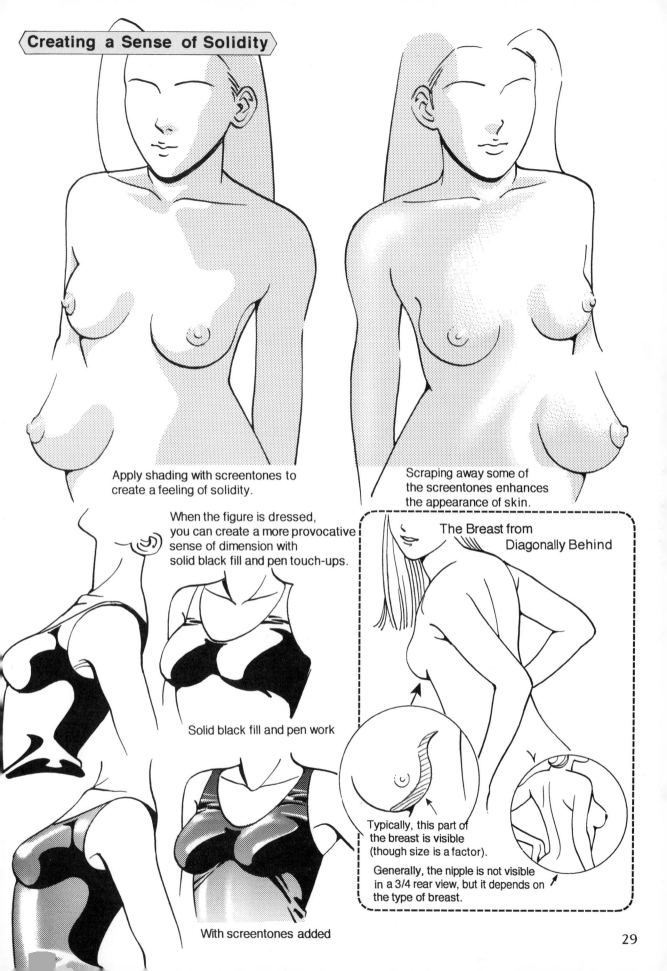

Apply shading with screentones to create a feeling of solidity.

Scraping away some of the screentones enhances the appearance of skin.

When the figure is dressed, you can create a more provocative sense of dimension with solid black fill and pen touch-ups.

Solid black fill and pen work

The Breast from Diagonally Behind

Typically, this part of the breast is visible (though size is a factor).

Generally, the nipple is not visible in a 3/4 rear view, but it depends on the type of breast.

With screentones added

29

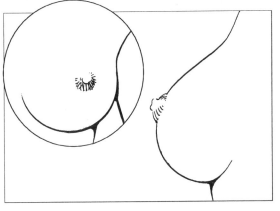

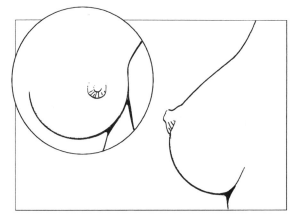

Since the areola is in effect a circle drawn on a sphere, it must be drawn with care in order to maintain proper perspective. When the areola will be toward the side, draw a circle on a ball first to see exactly what shape it needs to be on paper.

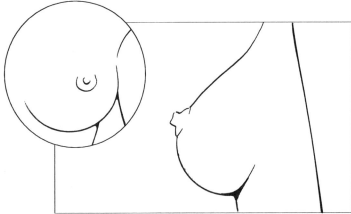

Some Examples

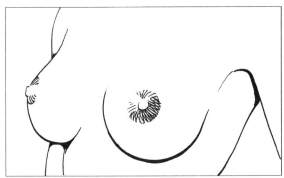

Pen work only

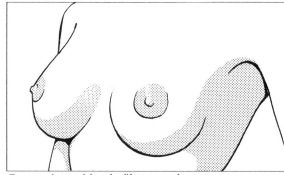

Pen work combined with screentones, handled with relative simplicity.

Screentones only, without any pen work.

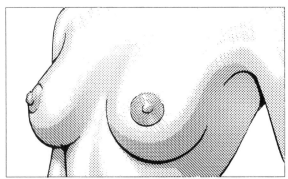

Combining pen work and layered screentones gives the drawing more dimension and makes the nipple and areola appear more real.

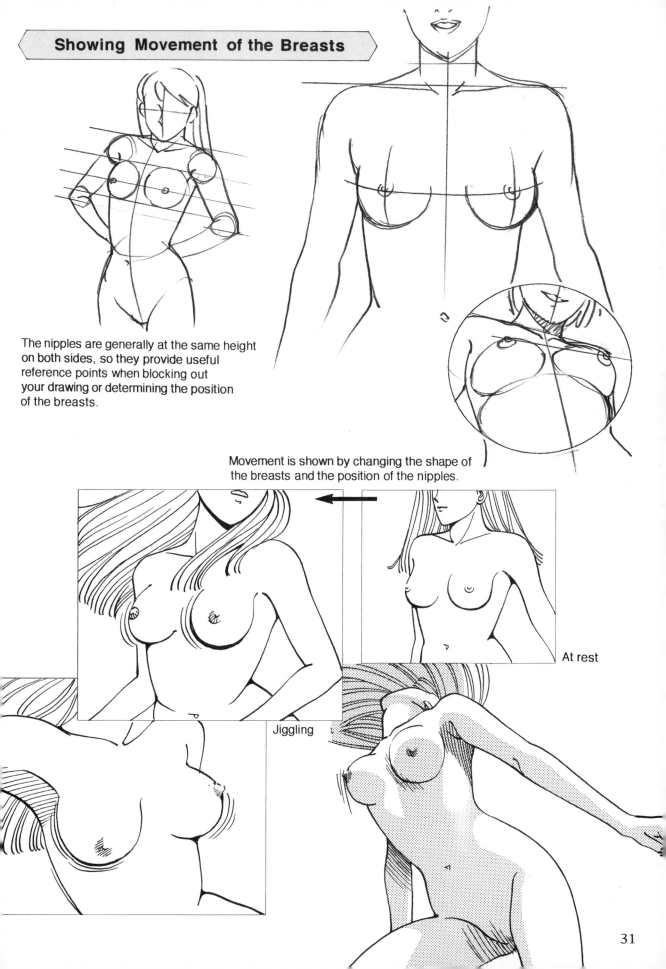

Showing Movement of the Breasts

The nipples are generally at the same height on both sides, so they provide useful reference points when blocking out your drawing or determining the position of the breasts.

Movement is shown by changing the shape of the breasts and the position of the nipples.

At rest

Jiggling

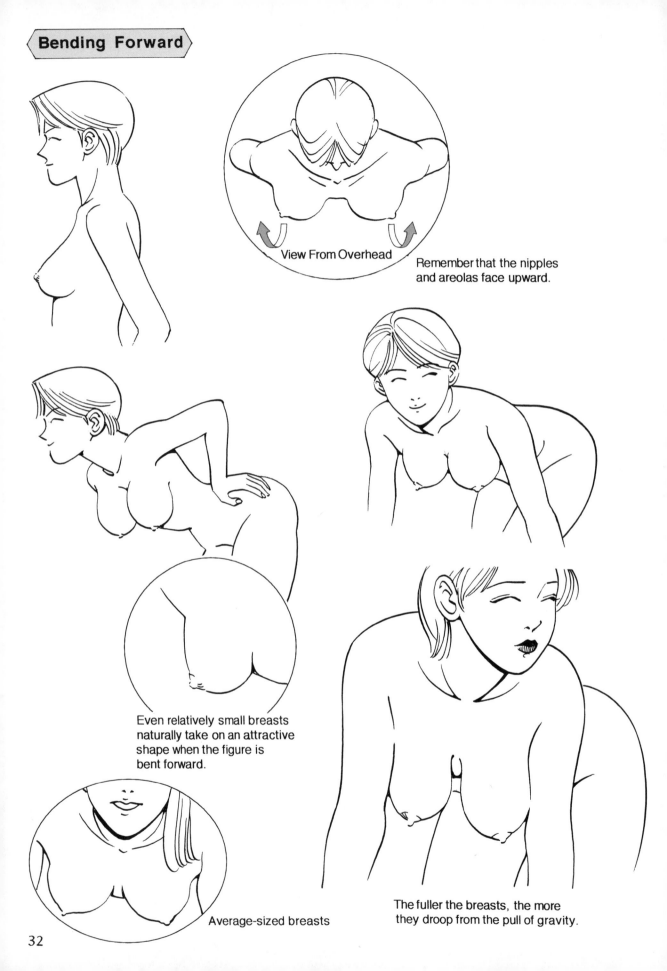

Bending Forward

View From Overhead

Remember that the nipples and areolas face upward.

Even relatively small breasts naturally take on an attractive shape when the figure is bent forward.

Average-sized breasts

The fuller the breasts, the more they droop from the pull of gravity.

Flat on the floor

The breasts press against the floor
and are flattened by the weight of the body.

The shape of the breasts is affected
by how much weight is being placed
on them (or not).

If the breasts are large, they take
the shape of a flattened ball.

How Moving the Shoulders and Arms Affects the Shape of the Breasts

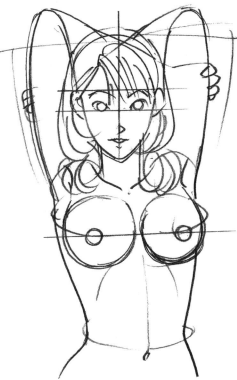

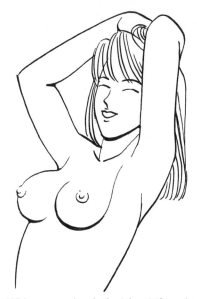

When the arms are raised, the muscles in the chest are also pulled upwards, and the breasts change shape.

With arms raised, the chest thrusts forward.

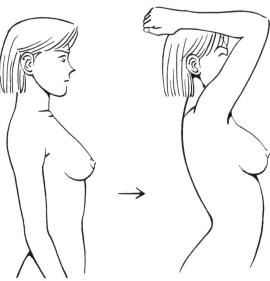

Subtle differences between when the arms are down and when they are raised can be seen clearly in side view.

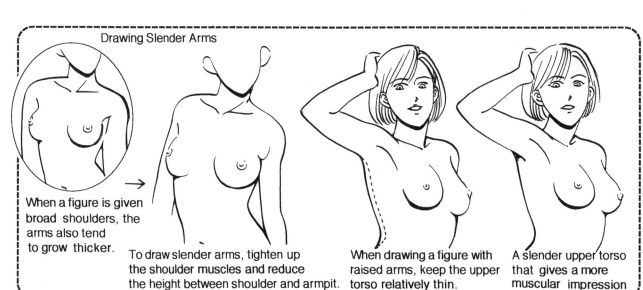

Drawing Slender Arms

When a figure is given broad shoulders, the arms also tend to grow thicker.

To draw slender arms, tighten up the shoulder muscles and reduce the height between shoulder and armpit.

When drawing a figure with raised arms, keep the upper torso relatively thin.

A slender upper torso that gives a more muscular impression

The Shape of the Breasts When Lying Face Up

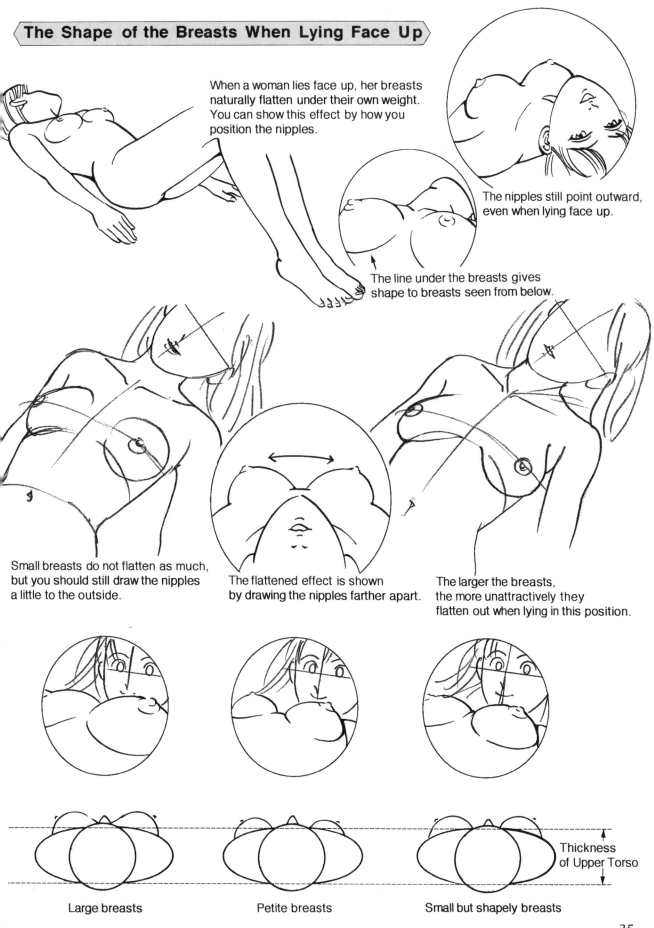

When a woman lies face up, her breasts naturally flatten under their own weight. You can show this effect by how you position the nipples.

The nipples still point outward, even when lying face up.

↑ The line under the breasts gives shape to breasts seen from below.

Small breasts do not flatten as much, but you should still draw the nipples a little to the outside.

The flattened effect is shown by drawing the nipples farther apart.

The larger the breasts, the more unattractively they flatten out when lying in this position.

Thickness of Upper Torso

Large breasts

Petite breasts

Small but shapely breasts

Effects You Can Achieve With the Breasts

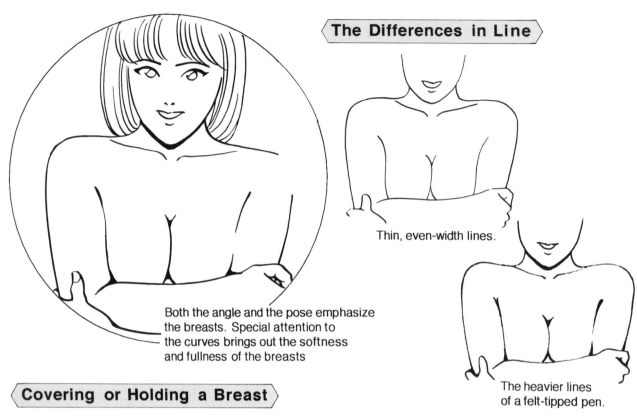

The Differences in Line

Thin, even-width lines.

Both the angle and the pose emphasize the breasts. Special attention to the curves brings out the softness and fullness of the breasts

The heavier lines of a felt-tipped pen.

Covering or Holding a Breast

A small breast covered with a hand

A larger breast

Nipple peeking slightly through the fingers

A small breast held firmly

Flesh pressing between the fingers shows the fullness of the breast.

Shift the position of the nipple to show softness or forceful manipulation of the breast.

Squeezing the Breasts Together

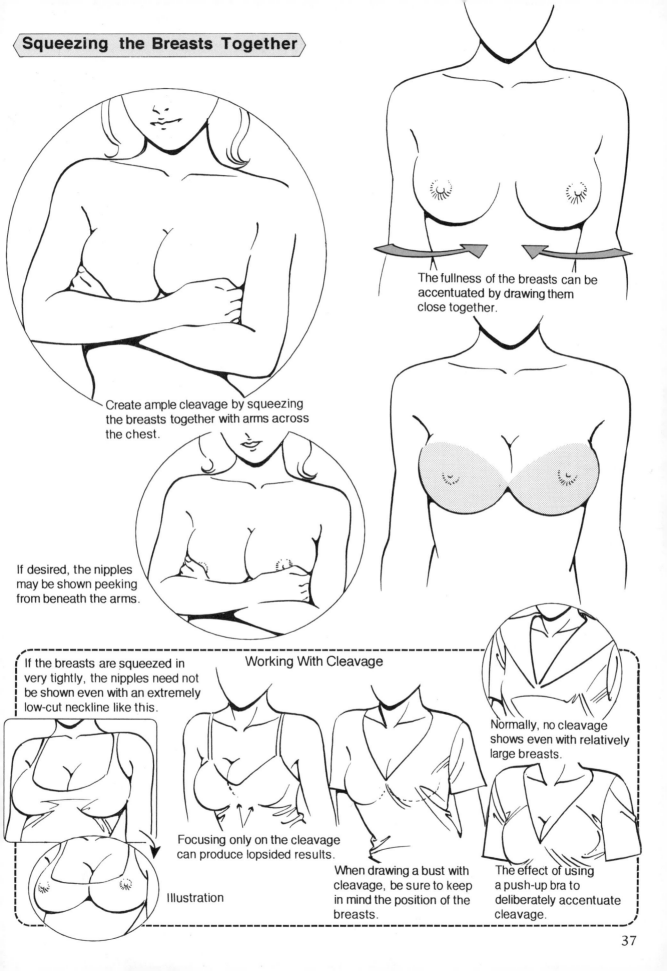

The fullness of the breasts can be accentuated by drawing them close together.

Create ample cleavage by squeezing the breasts together with arms across the chest.

If desired, the nipples may be shown peeking from beneath the arms.

If the breasts are squeezed in very tightly, the nipples need not be shown even with an extremely low-cut neckline like this.

Illustration

Working With Cleavage

Focusing only on the cleavage can produce lopsided results.

When drawing a bust with cleavage, be sure to keep in mind the position of the breasts.

Normally, no cleavage shows even with relatively large breasts.

The effect of using a push-up bra to deliberately accentuate cleavage.

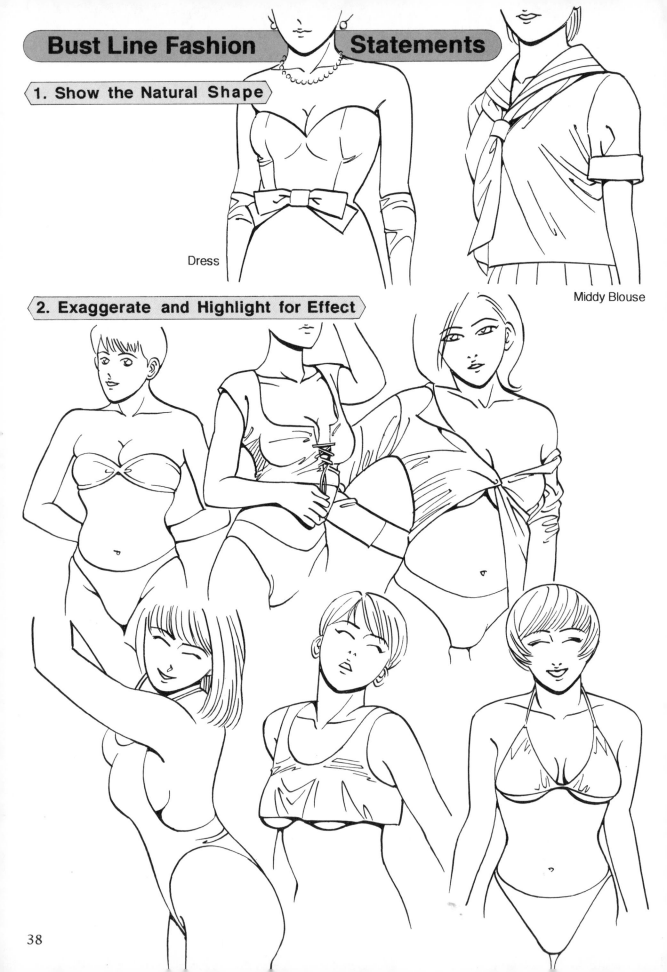

Bust Line Fashion Statements

1. Show the Natural Shape

Dress

Middy Blouse

2. Exaggerate and Highlight for Effect

Styles of Neckline

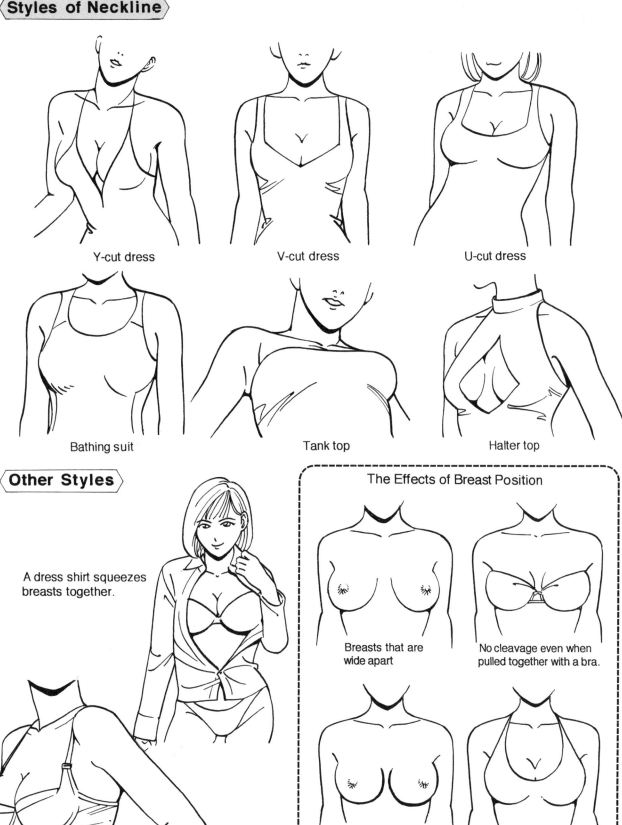

Y-cut dress

V-cut dress

U-cut dress

Bathing suit

Tank top

Halter top

Other Styles

A dress shirt squeezes breasts together.

Push-up bra

The Effects of Breast Position

Breasts that are wide apart

No cleavage even when pulled together with a bra.

Breasts that are close together

The slightest pull creates cleavage (though only if full-figured).

The Buttocks

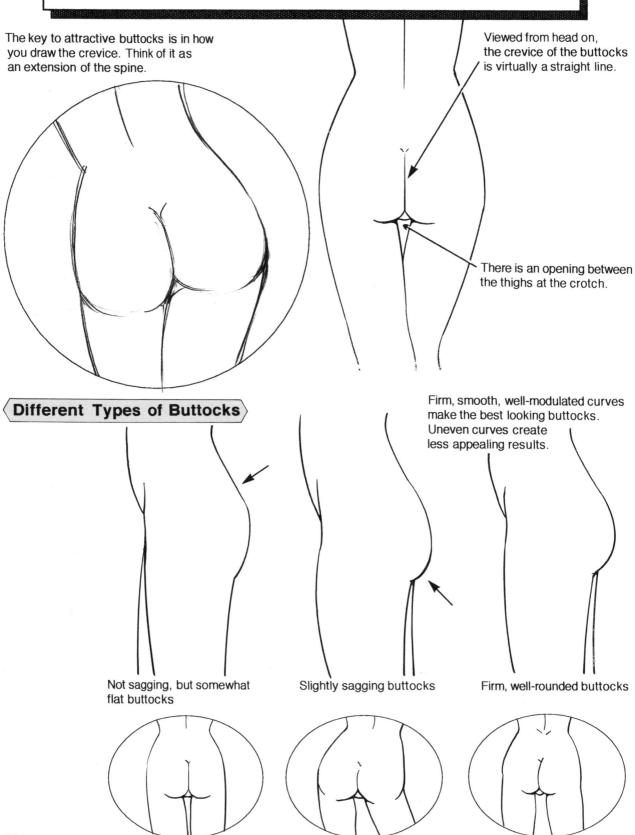

The key to attractive buttocks is in how you draw the crevice. Think of it as an extension of the spine.

Viewed from head on, the crevice of the buttocks is virtually a straight line.

There is an opening between the thighs at the crotch.

Different Types of Buttocks

Firm, smooth, well-modulated curves make the best looking buttocks. Uneven curves create less appealing results.

Not sagging, but somewhat flat buttocks

Slightly sagging buttocks

Firm, well-rounded buttocks

Different Views of the Buttocks

Realistic buttocks

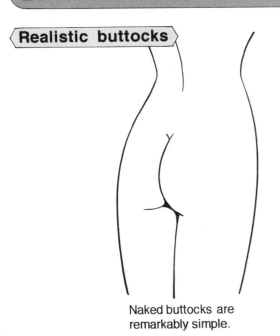

Naked buttocks are remarkably simple.

Buttocks and Hearts

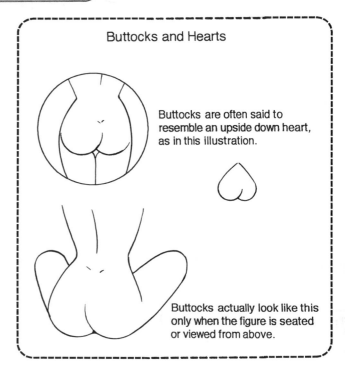

Buttocks are often said to resemble an upside down heart, as in this illustration.

Buttocks actually look like this only when the figure is seated or viewed from above.

Manga buttocks

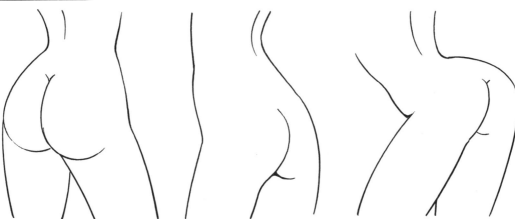

"Covered" buttocks

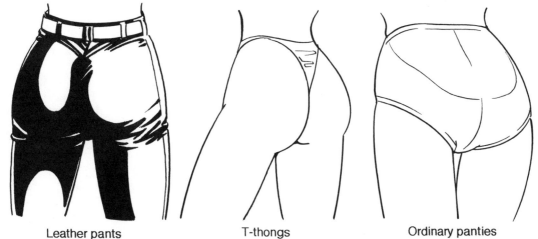

Leather pants T-thongs Ordinary panties

41

The Contour of the Buttocks

The secret to drawing an attractive buttocks is in thinking of the crevice as an extension of the spine.

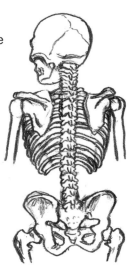

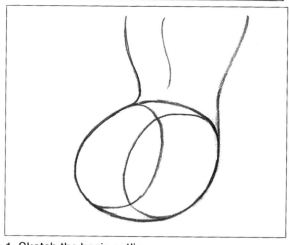

1. Sketch the basic outlines

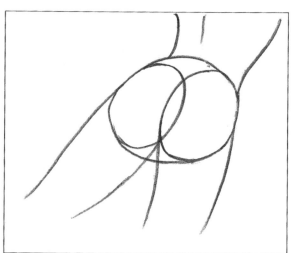

2. Draw the legs. The buttocks do not really take shape yet.

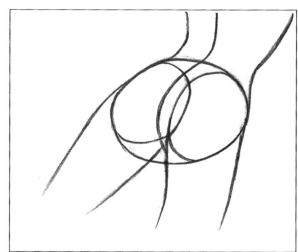

3. Extend the line of the spine along the curve of the buttocks.

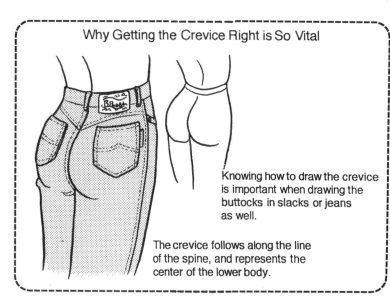

Why Getting the Crevice Right is So Vital

Knowing how to draw the crevice is important when drawing the buttocks in slacks or jeans as well.

The crevice follows along the line of the spine, and represents the center of the lower body.

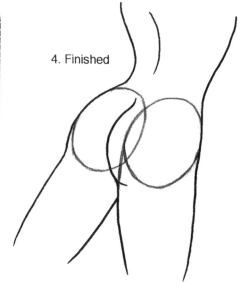

4. Finished

The Buttocks from a Low Angle

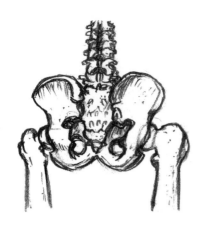

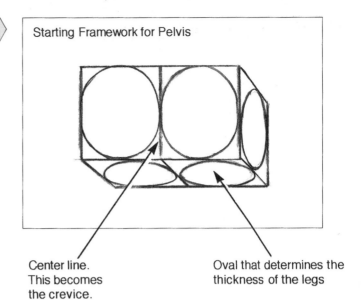

Starting Framework for Pelvis

Center line.
This becomes
the crevice.

Oval that determines the
thickness of the legs

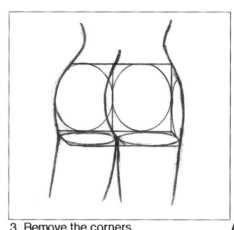

2. Draw the legs.

3. Remove the corners
and fill in the curves.

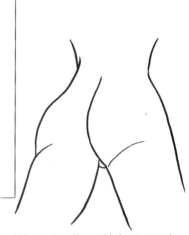

When standing with legs apart

The Buttocks When Walking

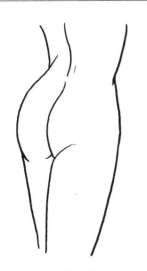

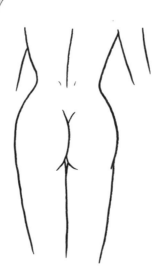

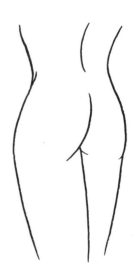

With the left foot forward

With the legs together

With the right foot forward

Effects You Can Achieve with the Buttocks

There are a fairly limited number of poses and angles that let you take advantage of the curvature and fullness of the buttocks.

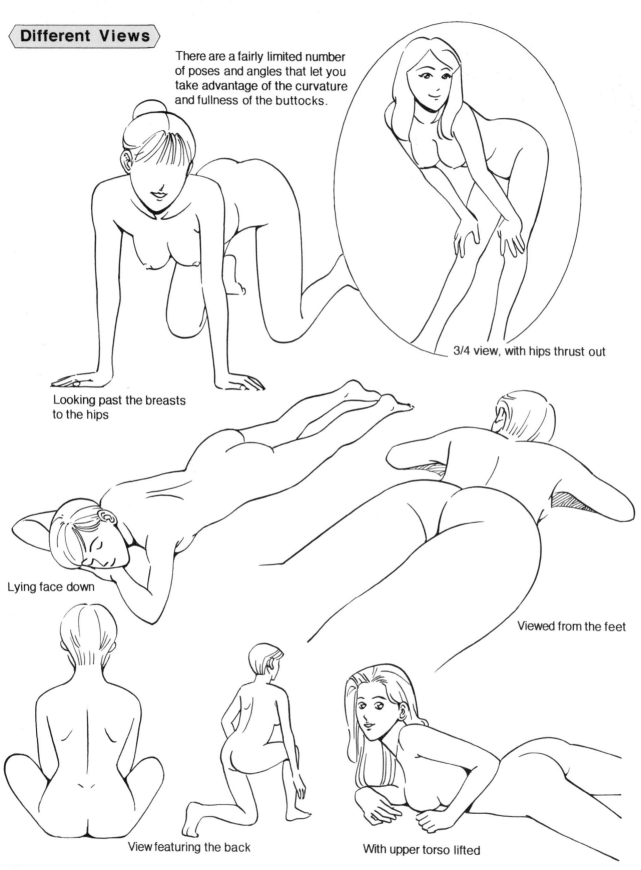

3/4 view, with hips thrust out

Looking past the breasts to the hips

Lying face down

Viewed from the feet

View featuring the back

With upper torso lifted

44

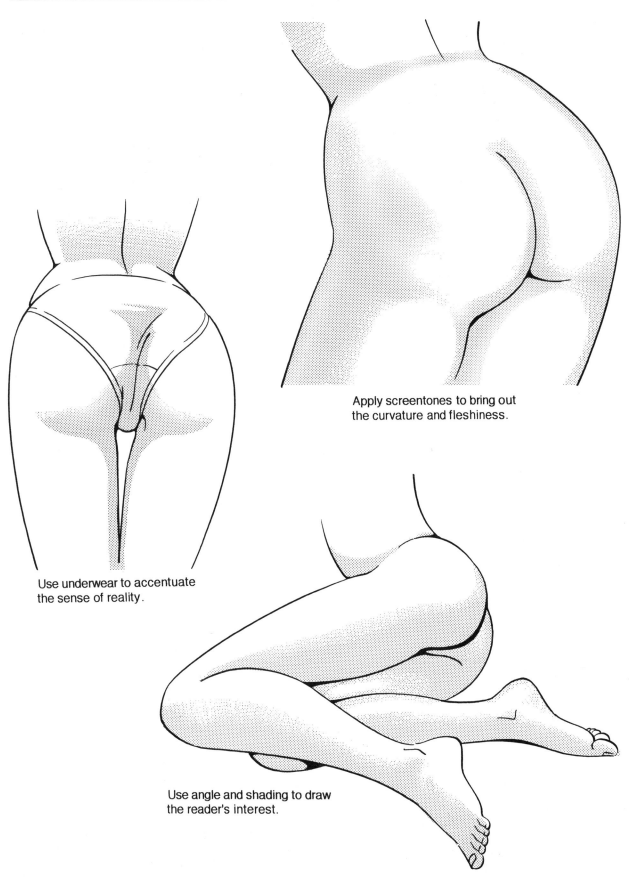

Apply screentones to bring out
the curvature and fleshiness.

Use underwear to accentuate
the sense of reality.

Use angle and shading to draw
the reader's interest.

The Crotch

Using Curved Lines to Show Dimension in the Crotch

1. Standing on Knees

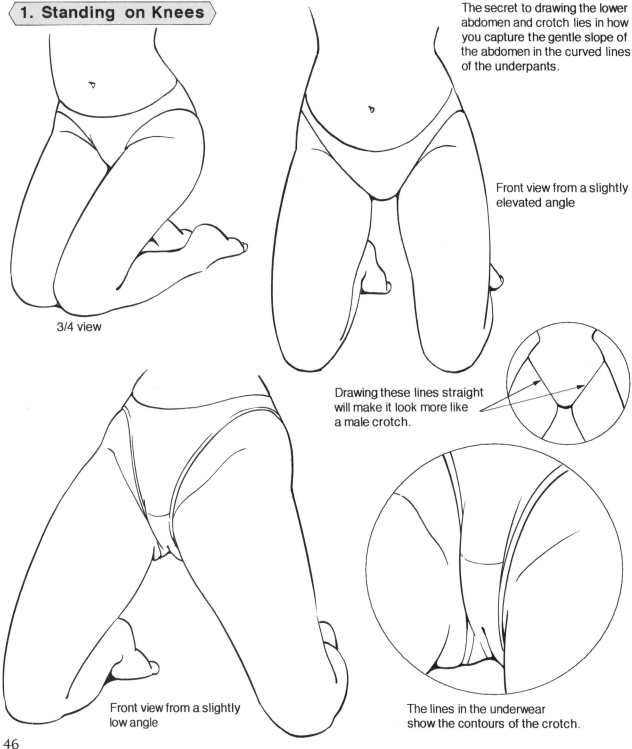

The secret to drawing the lower abdomen and crotch lies in how you capture the gentle slope of the abdomen in the curved lines of the underpants.

3/4 view

Front view from a slightly elevated angle

Drawing these lines straight will make it look more like a male crotch.

Front view from a slightly low angle

The lines in the underwear show the contours of the crotch.

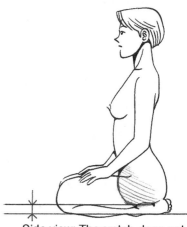

2. Sitting on Knees

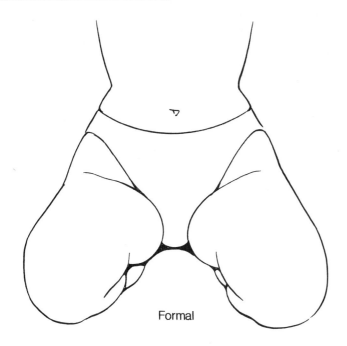

Formal

Side view: The crotch does not touch the floor.

The buttocks are soft, so the heel digs in.

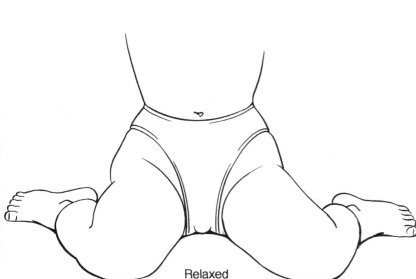

Relaxed

When the legs turn outward, the buttocks are pulled apart and the crevice opens up.

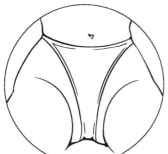

Wearing high-cut or string bikini-type underwear

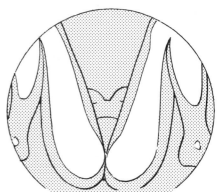

View from below: the thighs and the buttocks press flat against the floor.

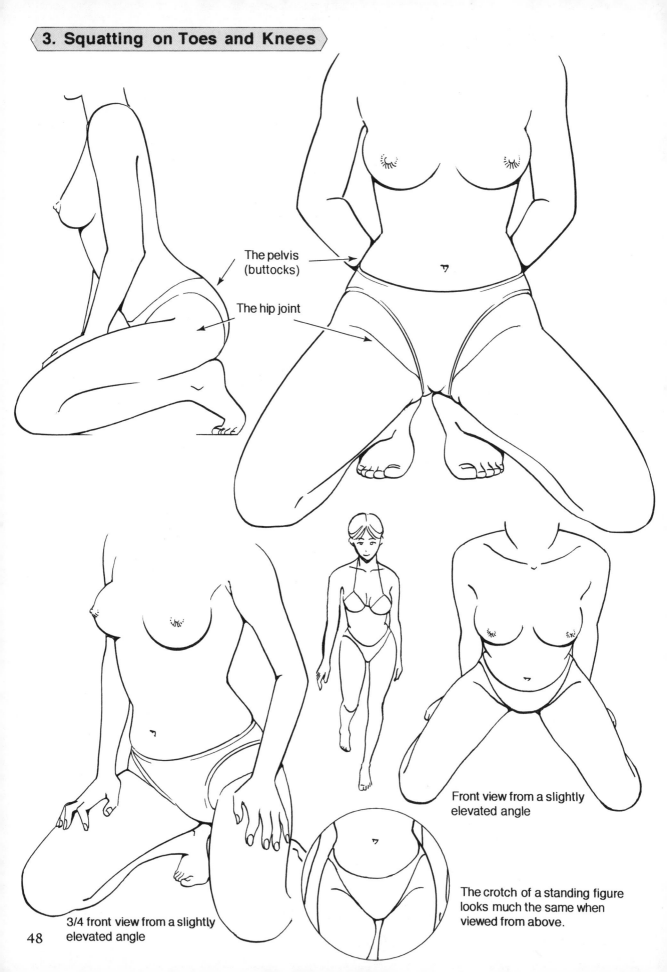

3. Squatting on Toes and Knees

The pelvis (buttocks)

The hip joint

Front view from a slightly elevated angle

3/4 front view from a slightly elevated angle

The crotch of a standing figure looks much the same when viewed from above.

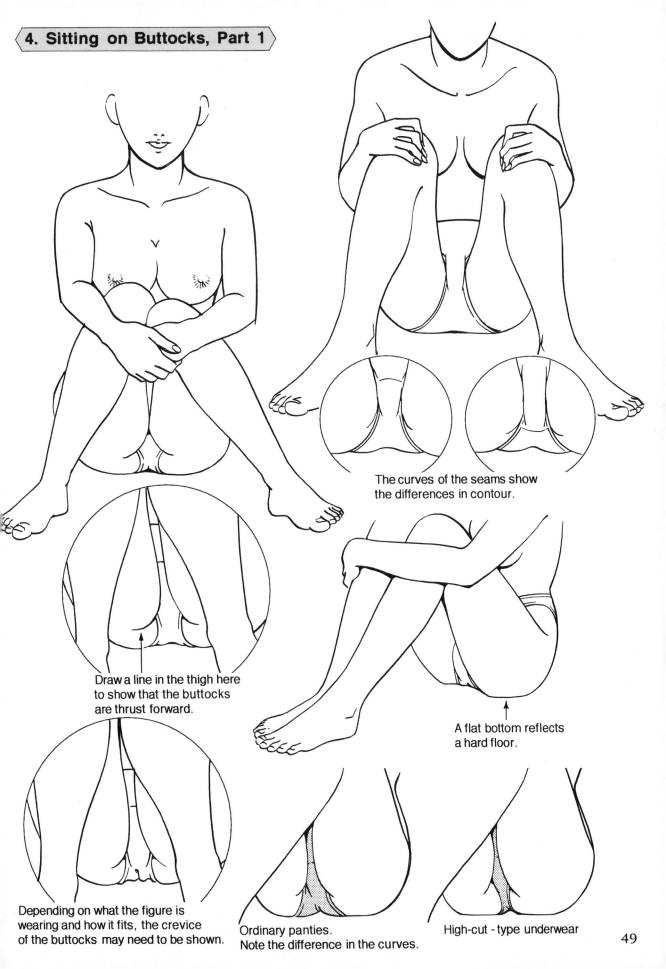

The curves of the seams show the differences in contour.

Draw a line in the thigh here to show that the buttocks are thrust forward.

A flat bottom reflects a hard floor.

Depending on what the figure is wearing and how it fits, the crevice of the buttocks may need to be shown.

Ordinary panties. Note the difference in the curves.

High-cut - type underwear

49

Even for essentially the same sitting position, the appearance of the crotch will be different depending on whether the figure is leaning forward or back.

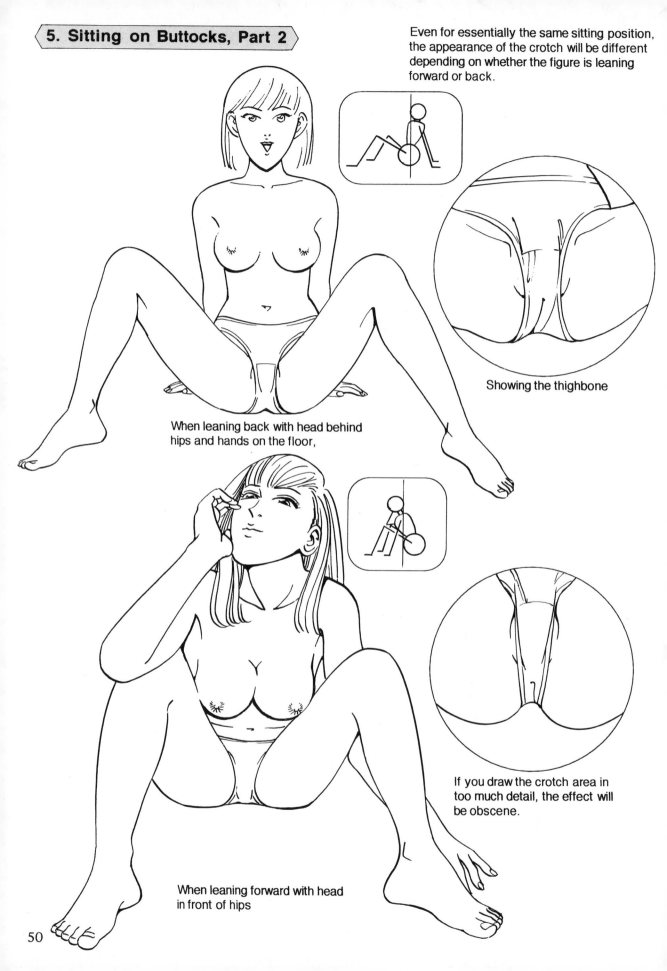

Showing the thighbone

When leaning back with head behind hips and hands on the floor,

If you draw the crotch area in too much detail, the effect will be obscene.

When leaning forward with head in front of hips

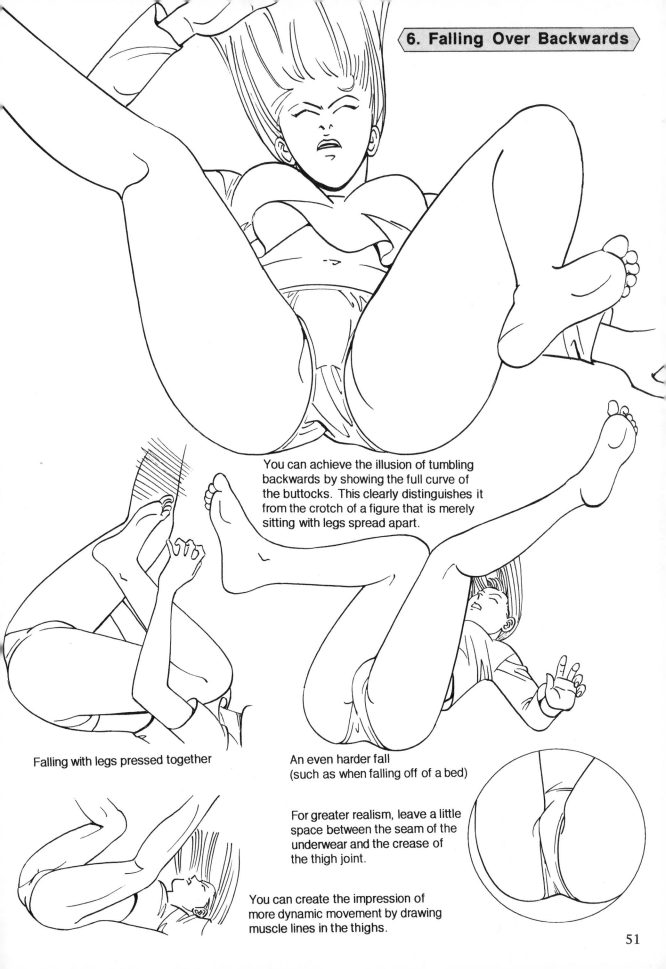

You can achieve the illusion of tumbling backwards by showing the full curve of the buttocks. This clearly distinguishes it from the crotch of a figure that is merely sitting with legs spread apart.

Falling with legs pressed together

An even harder fall
(such as when falling off of a bed)

For greater realism, leave a little space between the seam of the underwear and the crease of the thigh joint.

You can create the impression of more dynamic movement by drawing muscle lines in the thighs.

51

The Lower Body in Action

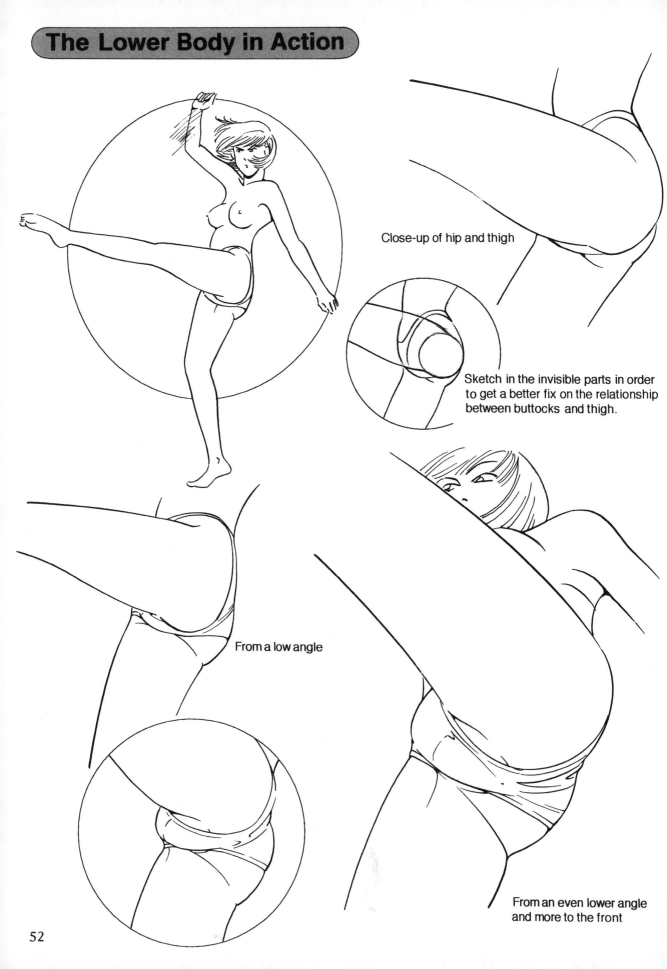

Close-up of hip and thigh

Sketch in the invisible parts in order to get a better fix on the relationship between buttocks and thigh.

From a low angle

From an even lower angle and more to the front

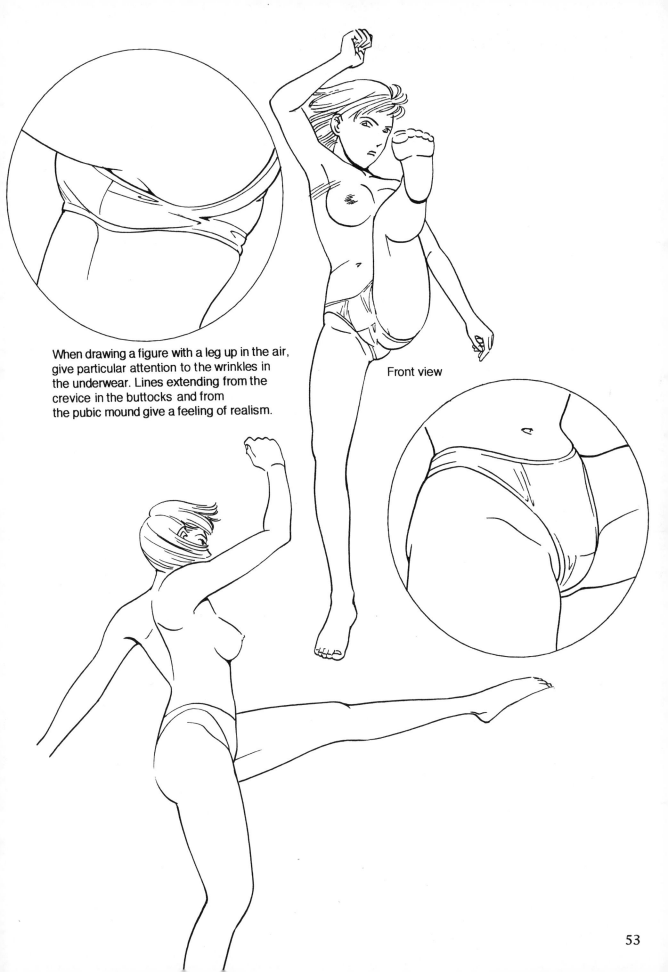

When drawing a figure with a leg up in the air, give particular attention to the wrinkles in the underwear. Lines extending from the crevice in the buttocks and from the pubic mound give a feeling of realism.

Front view

The Relation Between the Buttocks, Crotch, and Legs

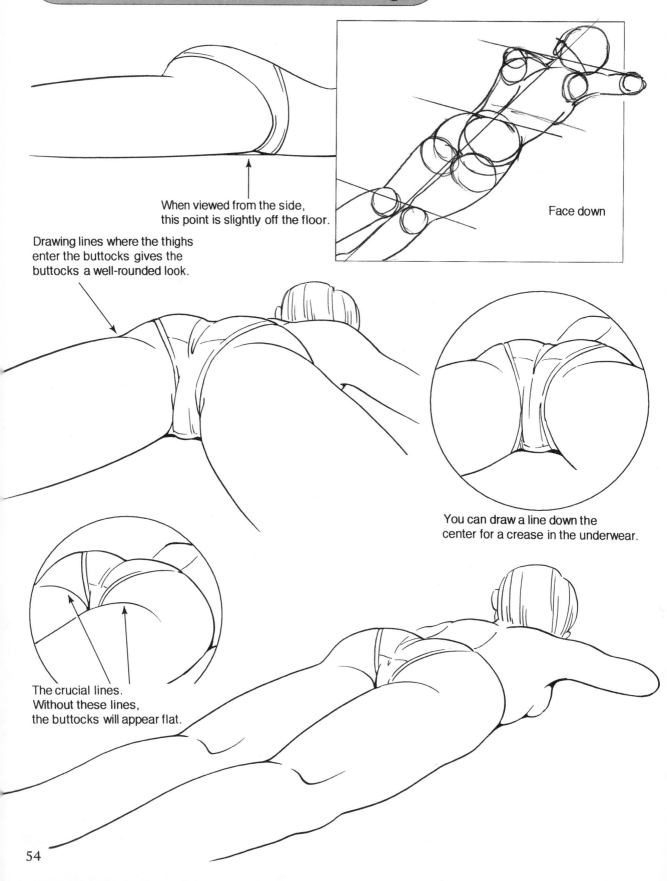

When viewed from the side, this point is slightly off the floor.

Face down

Drawing lines where the thighs enter the buttocks gives the buttocks a well-rounded look.

You can draw a line down the center for a crease in the underwear.

The crucial lines. Without these lines, the buttocks will appear flat.

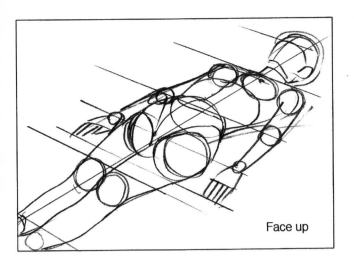

Face up

On a hard floor, there will be a gap
between the waist and the floor.

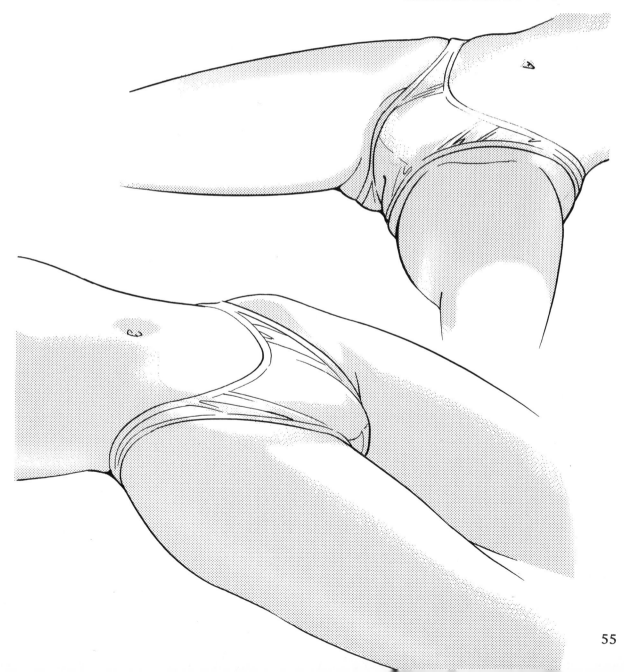

The Legs

The bones X-ray view

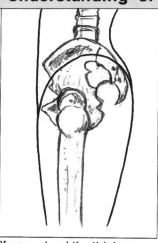

If you extend the thigh
directly off of the buttocks,
it will tend to be quite fat.

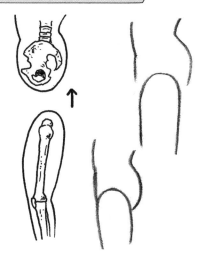

When you want to draw a less beefy thigh,
draw the thigh first in the desired proportions,
and then adjust the buttocks as necessary
for a natural fit.

A Side View of the Leg at the Hip

The thickness of the thigh where it attaches
to the pelvis determines the shape of the buttocks.

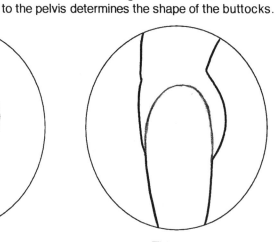

Thick thigh Average thigh Thin thigh

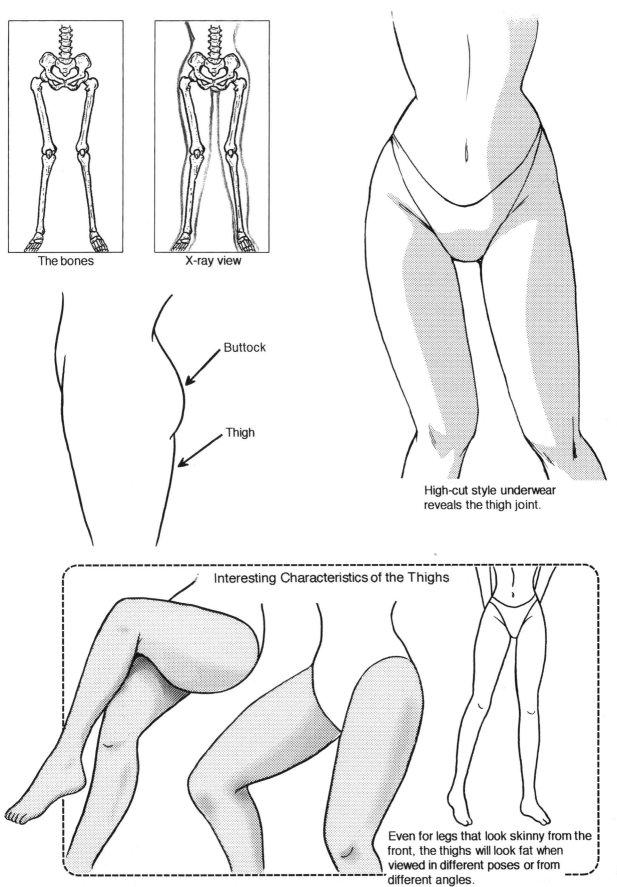

The bones

X-ray view

Buttock

Thigh

High-cut style underwear reveals the thigh joint.

Interesting Characteristics of the Thighs

Even for legs that look skinny from the front, the thighs will look fat when viewed in different poses or from different angles.

57

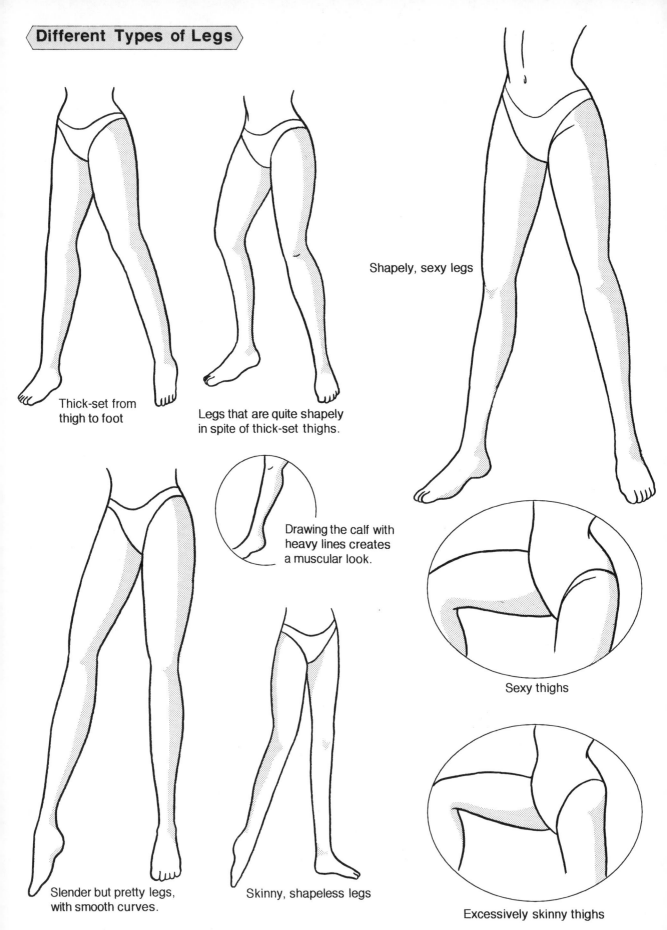

Different Types of Legs

Thick-set from thigh to foot

Legs that are quite shapely in spite of thick-set thighs.

Shapely, sexy legs

Drawing the calf with heavy lines creates a muscular look.

Slender but pretty legs, with smooth curves.

Skinny, shapeless legs

Sexy thighs

Excessively skinny thighs

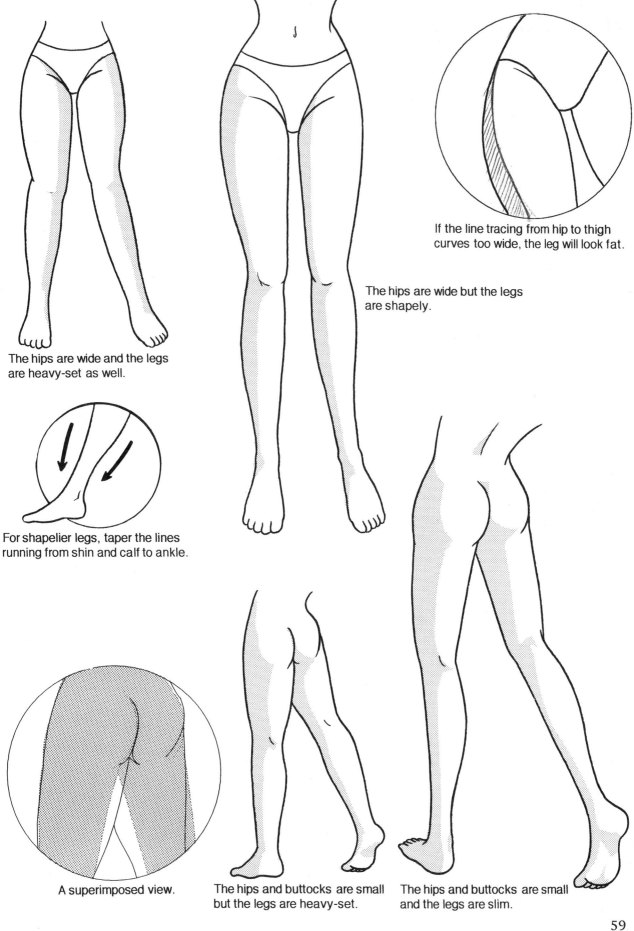

The hips are wide and the legs are heavy-set as well.

If the line tracing from hip to thigh curves too wide, the leg will look fat.

The hips are wide but the legs are shapely.

For shapelier legs, taper the lines running from shin and calf to ankle.

A superimposed view.

The hips and buttocks are small but the legs are heavy-set.

The hips and buttocks are small and the legs are slim.

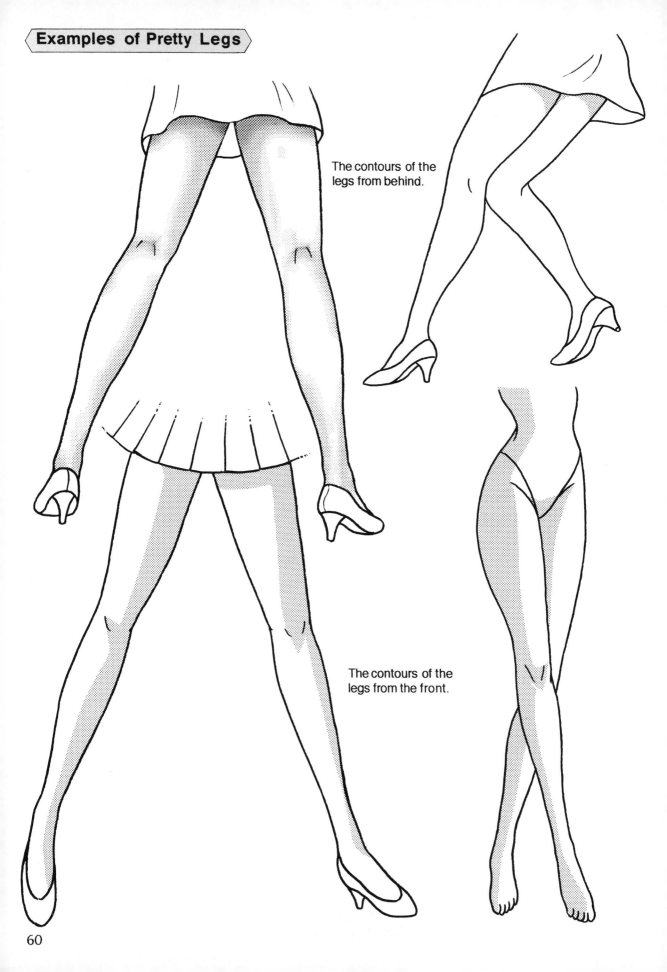

The contours of the legs from behind.

The contours of the legs from the front.

Various ways to Draw Knees

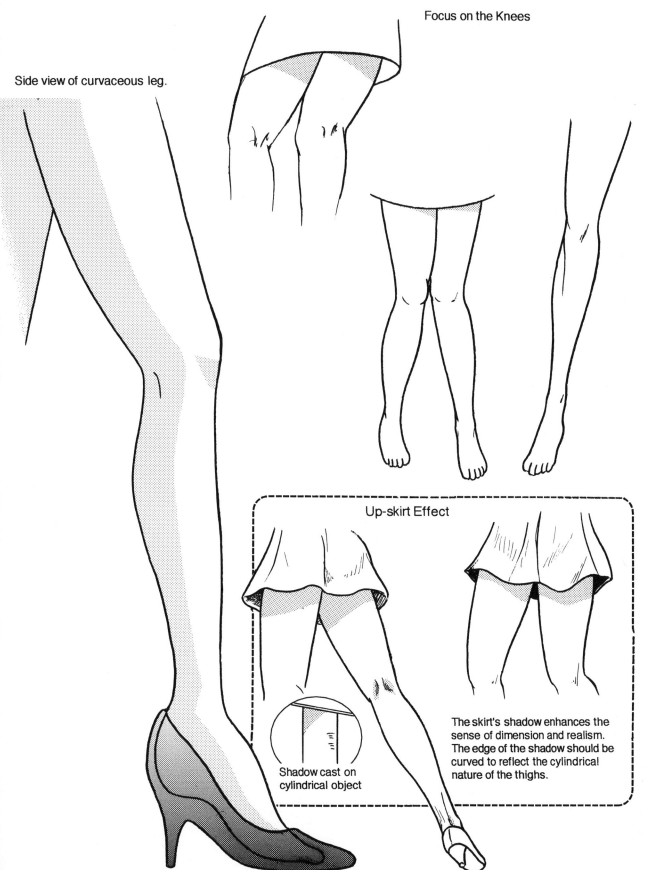

Side view of curvaceous leg.

Focus on the Knees

Up-skirt Effect

Shadow cast on
cylindrical object

The skirt's shadow enhances the
sense of dimension and realism.
The edge of the shadow should be
curved to reflect the cylindrical
nature of the thighs.

The Softness of the Buttocks and Legs

The buttocks and thighs are quite soft, and they change shape according to how weight is being placed on them as well as how hard or soft the underlying surface is.

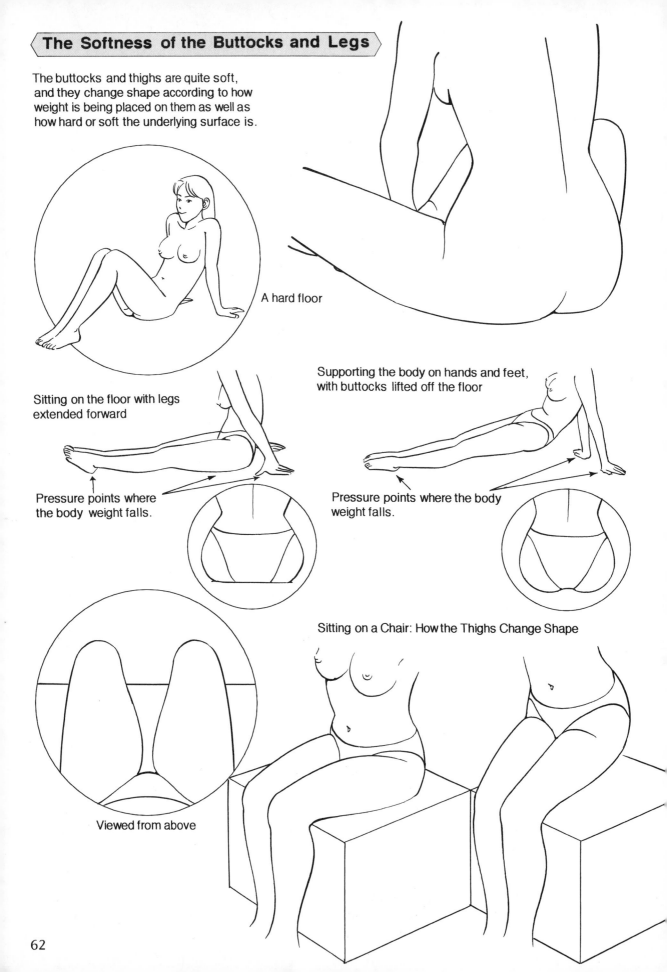

A hard floor

Sitting on the floor with legs extended forward

Pressure points where the body weight falls.

Supporting the body on hands and feet, with buttocks lifted off the floor

Pressure points where the body weight falls.

Sitting on a Chair: How the Thighs Change Shape

Viewed from above

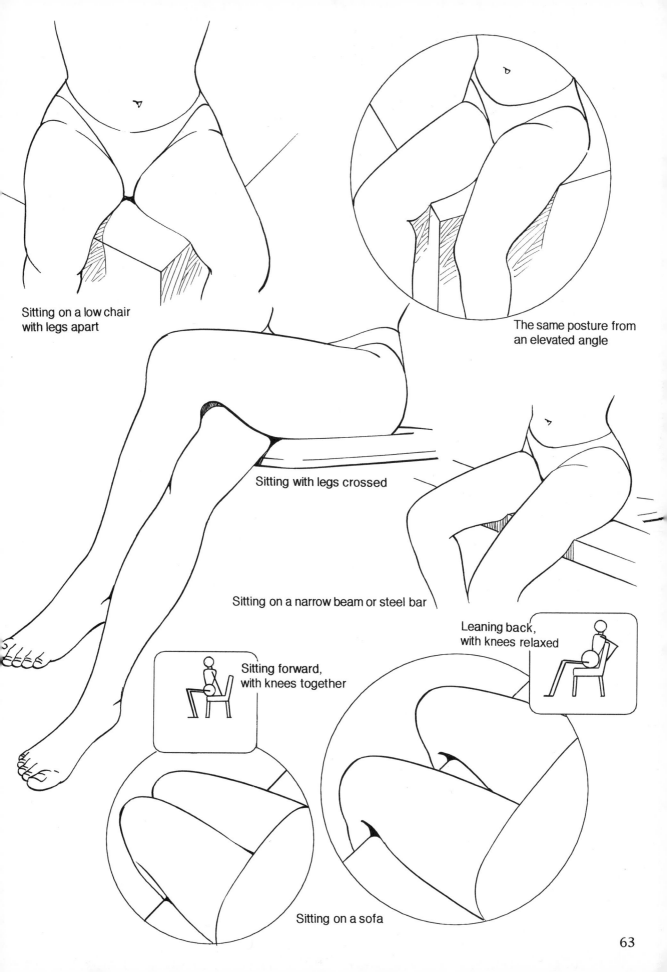

Sitting on a low chair with legs apart

The same posture from an elevated angle

Sitting with legs crossed

Sitting on a narrow beam or steel bar

Sitting forward, with knees together

Leaning back, with knees relaxed

Sitting on a sofa

The Neck

Connecting the Head to the Body

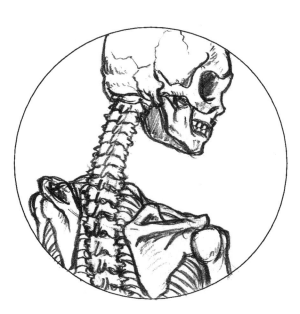

Looking Down From Above

The relative positions of head, neck and torso are easier to see if you draw them from an overhead perspective. Draw the figure in stages, adding one element at a time.

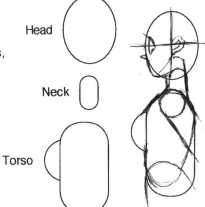

Head

Neck

Torso

4. Finished.

3. Add the head.

2. Add the neck.

1. Draw the body.

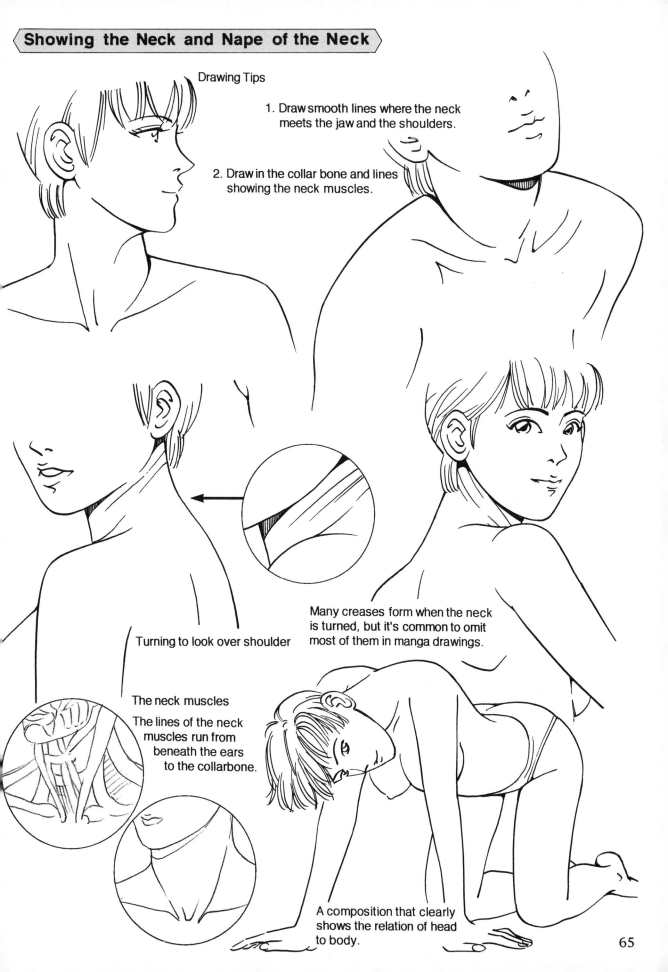

Showing the Neck and Nape of the Neck

Drawing Tips

1. Draw smooth lines where the neck meets the jaw and the shoulders.

2. Draw in the collar bone and lines showing the neck muscles.

Turning to look over shoulder

Many creases form when the neck is turned, but it's common to omit most of them in manga drawings.

The neck muscles

The lines of the neck muscles run from beneath the ears to the collarbone.

A composition that clearly shows the relation of head to body.

The Bent Back

When You Can't Draw a Tapered Waist

When a woman bends forward with a rounded back, creases form across her stomach no matter how trim she might be.

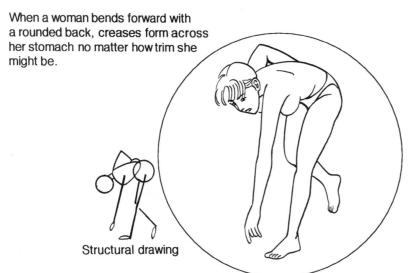

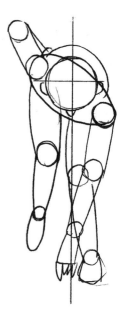

Structural drawing

Reaching to pick something up

Structurally speaking, one side constricts while the other stretches.

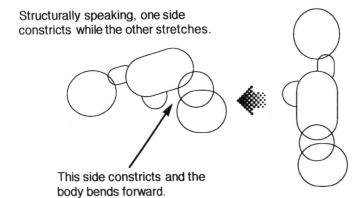

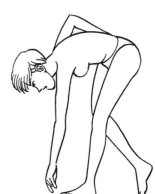

This side constricts and the body bends forward.

Bending Over in Other Ways

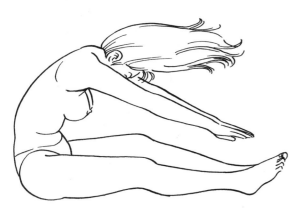

When knocked forcefully off one's feet

Depending on the posture and the angle,
the stomach creases may or may not show.
To avoid the appearance of a fat belly,
keep the creases to a minimum in your drawing.

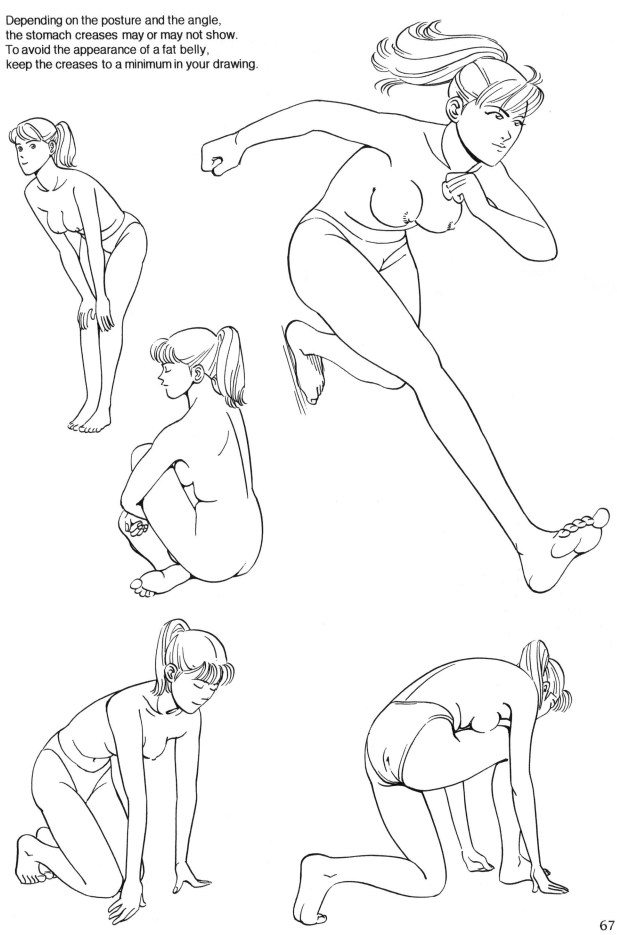

The Effect of Underwear and Bathing Suits on the Female Figure

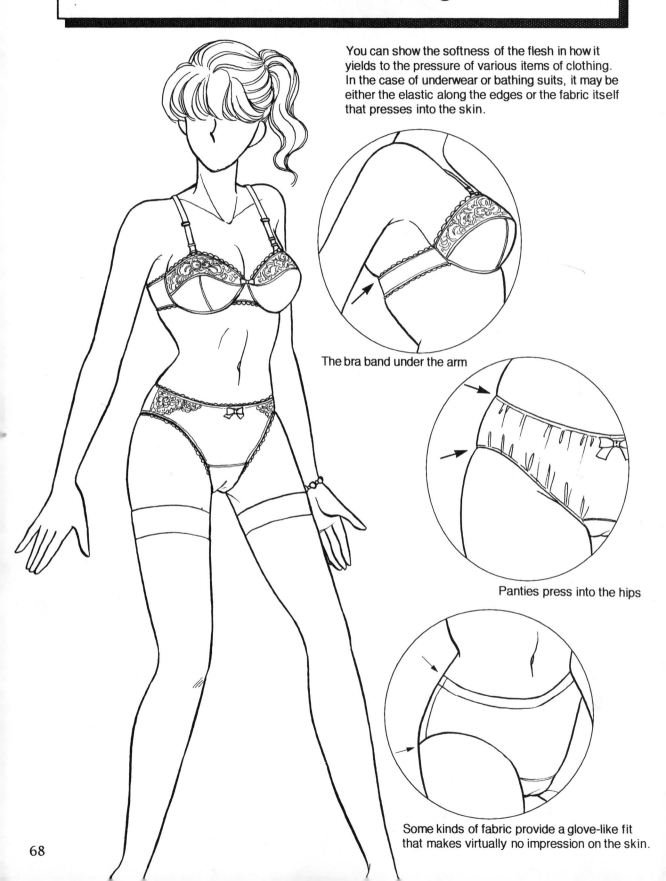

You can show the softness of the flesh in how it yields to the pressure of various items of clothing. In the case of underwear or bathing suits, it may be either the elastic along the edges or the fabric itself that presses into the skin.

The bra band under the arm

Panties press into the hips

Some kinds of fabric provide a glove-like fit that makes virtually no impression on the skin.

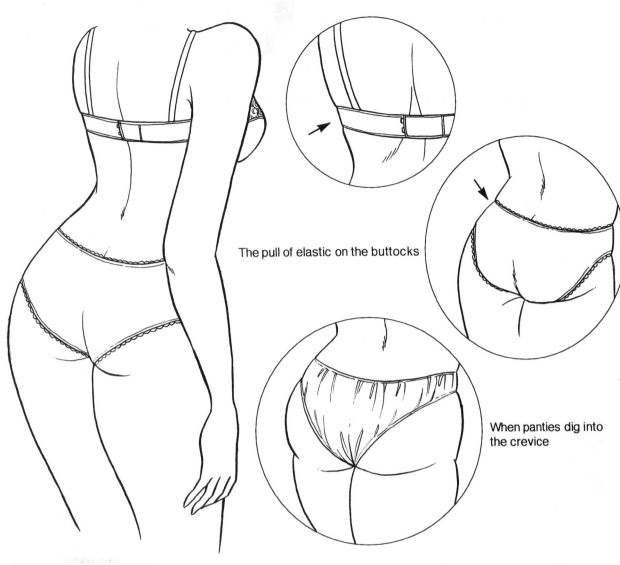

The pull of elastic on the buttocks

When panties dig into the crevice

Other Examples

Some body suits alter the person's entire figure.

Natural figure

With body suit

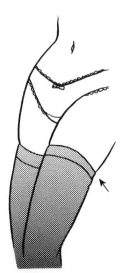

Long tights pressing into thighs

A bathing suit that's one size too small

Water Droplets and Beads of Sweat

Always keep the contours of the body in mind when drawing droplets of water or sweat.

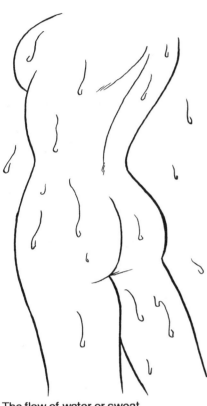

The flow of water or sweat should follow the body's curves.

1. Water flows along body contours.

Don't simply draw little round circles. Always remember that the beads of water or sweat lie on a curved surface.

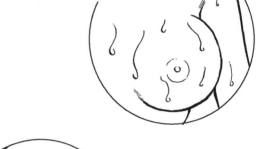

If you simply draw little round circles, they will look like drops of water resting on a sheet of glass in front of the figure.

2. Water obeys the rules of gravity.

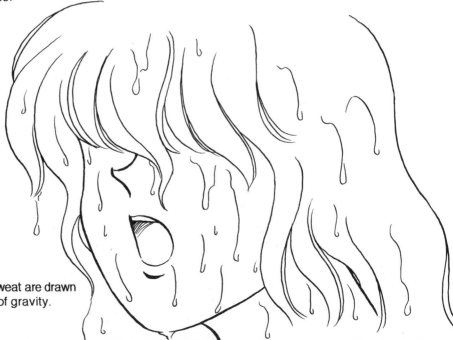

Beads of water and sweat are drawn downward by the pull of gravity.

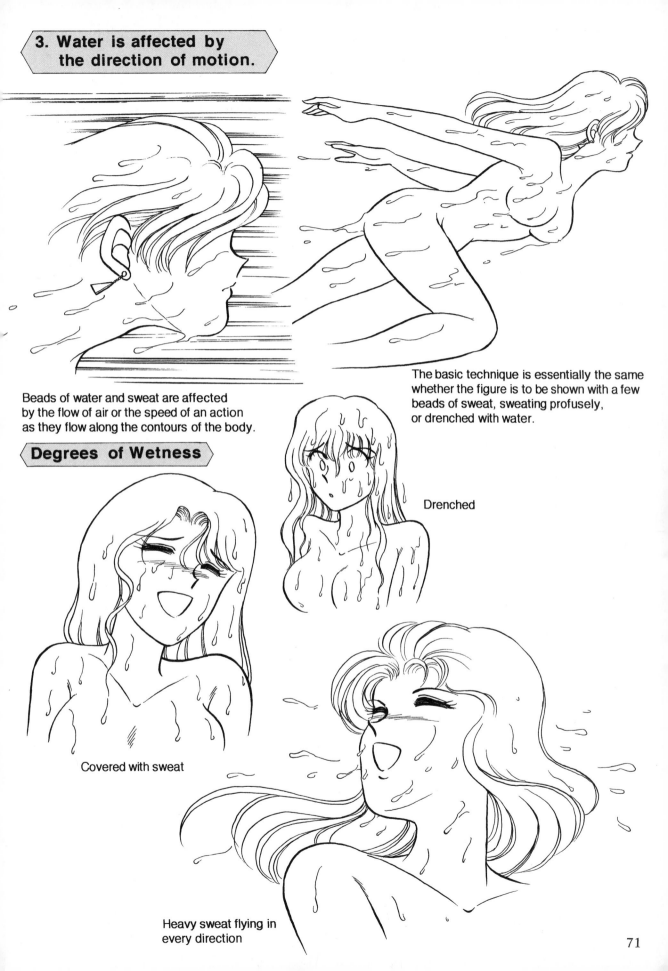

3. Water is affected by the direction of motion.

Beads of water and sweat are affected by the flow of air or the speed of an action as they flow along the contours of the body.

The basic technique is essentially the same whether the figure is to be shown with a few beads of sweat, sweating profusely, or drenched with water.

Degrees of Wetness

Drenched

Covered with sweat

Heavy sweat flying in every direction

Wire Frames

Getting a Grasp of the Body's Curves

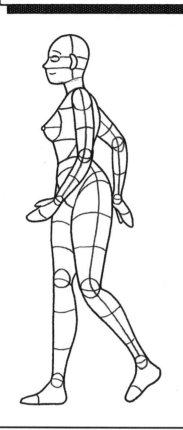

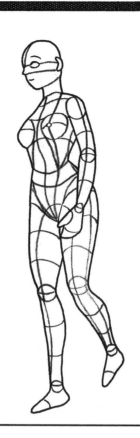

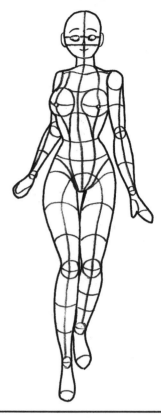

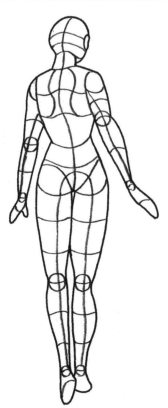

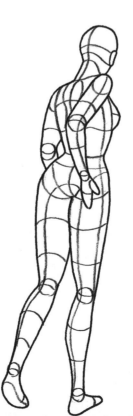

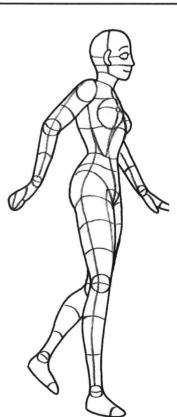

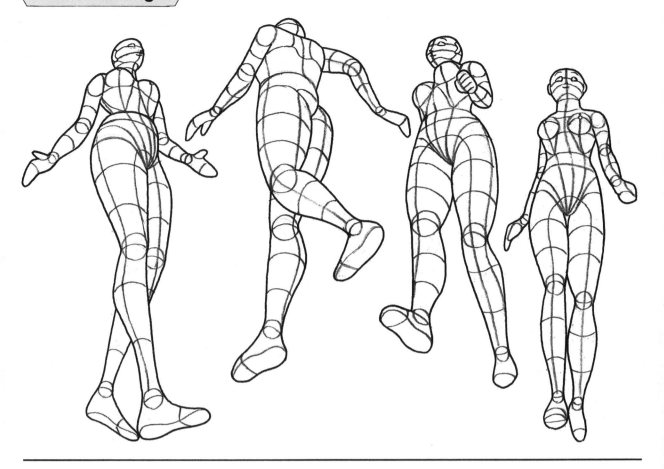

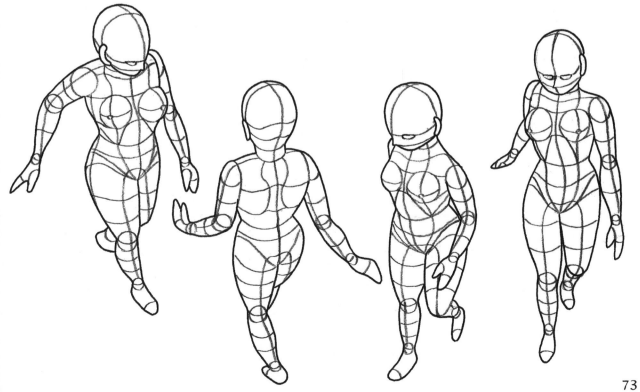

Using Wire Frames

Undergarments and clothing of all kinds generally conform to the contours of the body. Wire frames are especially helpful when drawing the ovoid curves at the neckline, the cuff of a sleeve, or the hem of a skirt.

The basic shape of a T-shirt and skirt

Clothing is in essence a figure's second skin.

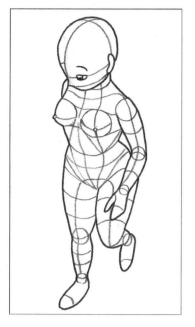

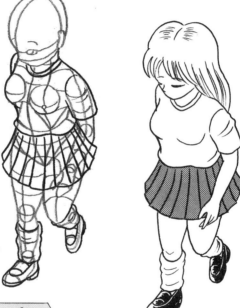

When drawing a V-neck, use the vertical lines for reference.

1. Drawing clothing

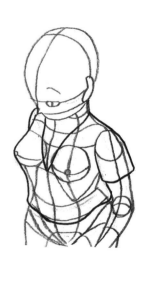

2. Drawing a figure in water

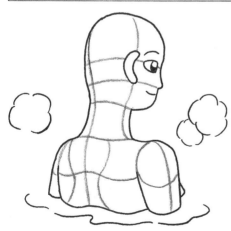

The surface of the water should follow the curves of the body.

3. Drawing logos

Refer to the wire frame when drawing logos and other designs on the clothing.

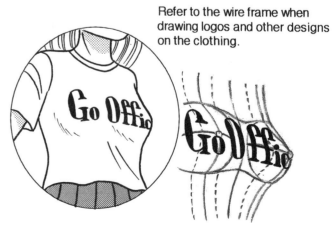

Go Office

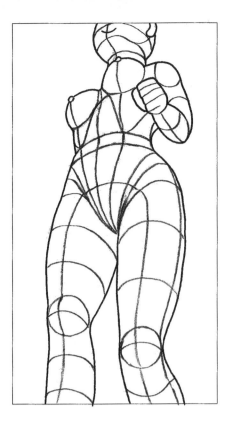

4. Drawing underpants

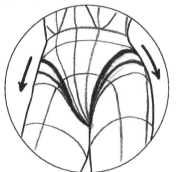

Following this line will give you high-cut panties.

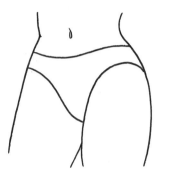

Choosing a lower line gives a more ordinary cut.

5. Drawing skirts

Refer to the wire frame to figure out
the curve of the skirt as seen from below.

Draw the desired clothing
over the frame to find the
appropriate curve.

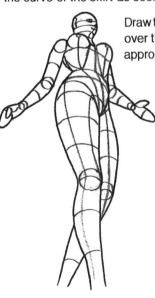

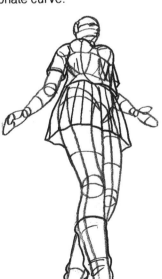

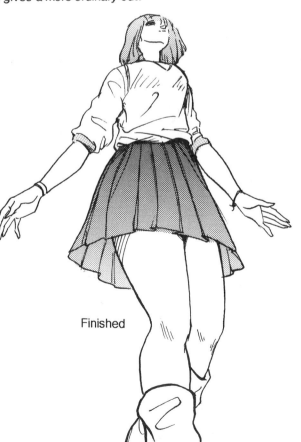

Finished

Wire frame of the desired angle

The frame also shows
the curve of the socks.

75

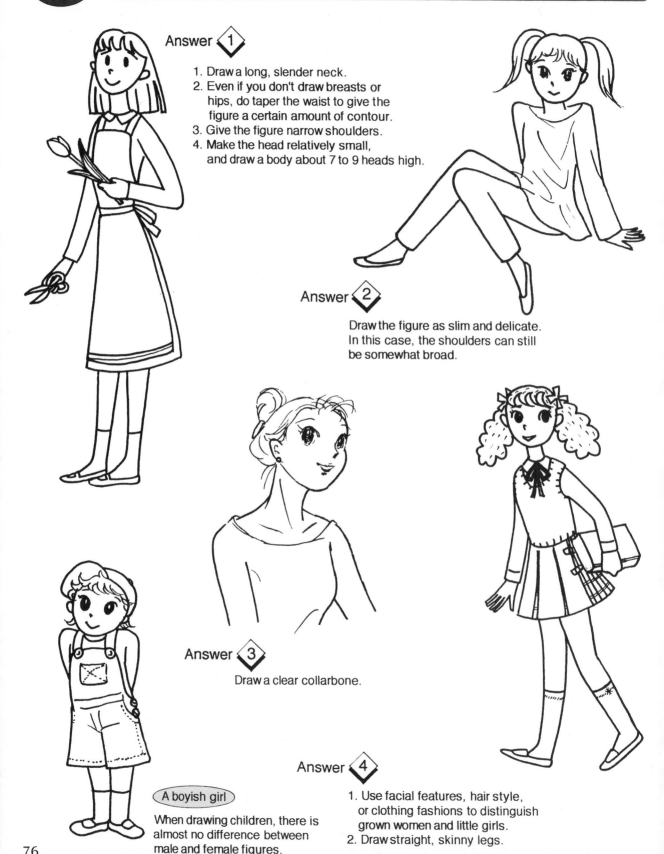

What if you want to draw a female figure without drawing attention to the bust or hips?

Answer 1

1. Draw a long, slender neck.
2. Even if you don't draw breasts or hips, do taper the waist to give the figure a certain amount of contour.
3. Give the figure narrow shoulders.
4. Make the head relatively small, and draw a body about 7 to 9 heads high.

Answer 2

Draw the figure as slim and delicate. In this case, the shoulders can still be somewhat broad.

Answer 3

Draw a clear collarbone.

Answer 4

1. Use facial features, hair style, or clothing fashions to distinguish grown women and little girls.
2. Draw straight, skinny legs.

A boyish girl

When drawing children, there is almost no difference between male and female figures.

Chapter 3

Drawing the Female Figure: Using Detail for Effect

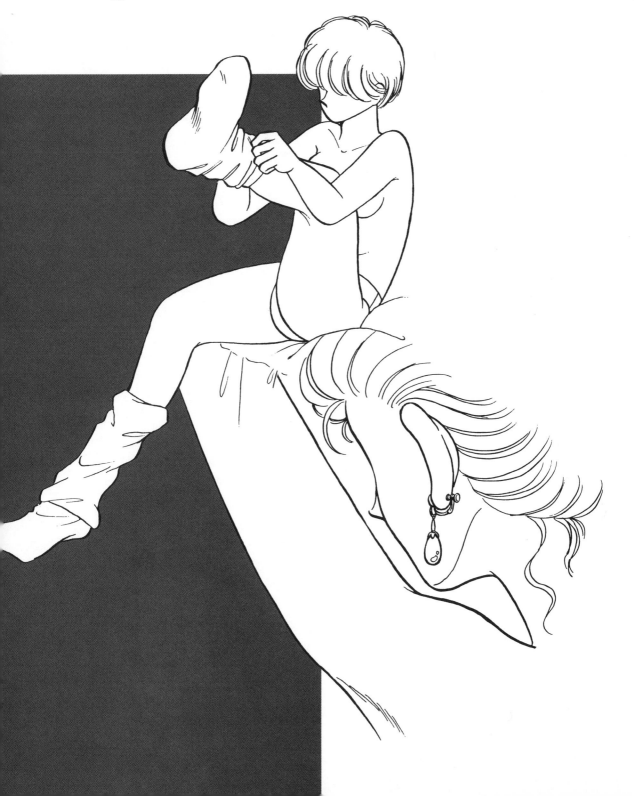

Different Types of Nails

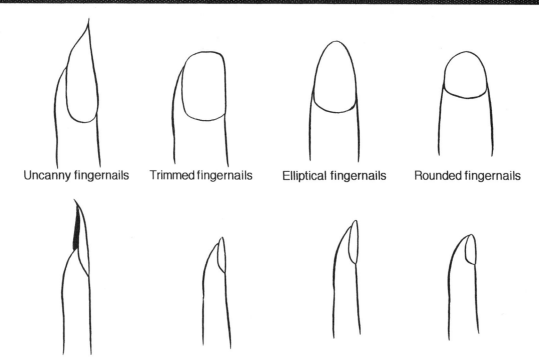

Uncanny fingernails Trimmed fingernails Elliptical fingernails Rounded fingernails

Examples of Hands and Nails

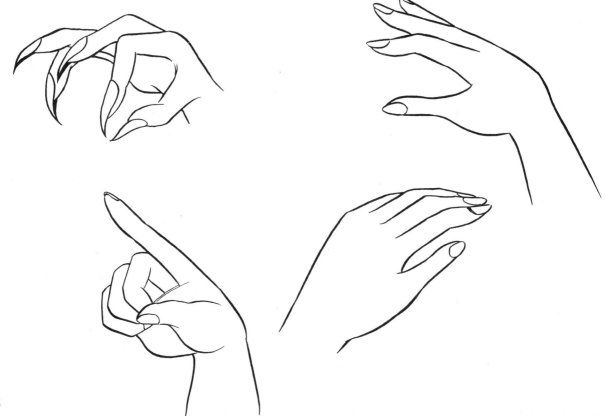

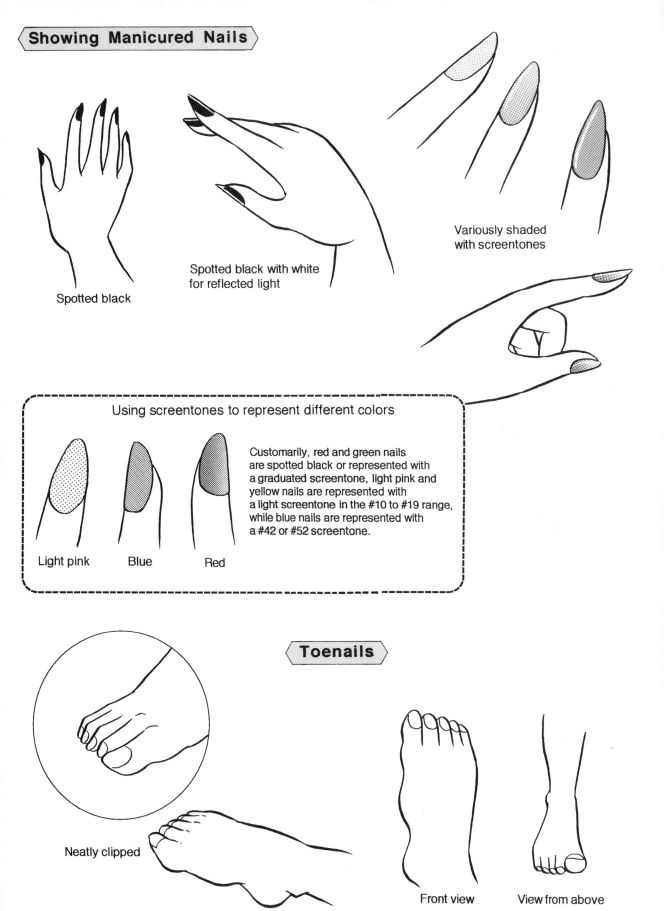

Showing Manicured Nails

Spotted black

Spotted black with white for reflected light

Variously shaded with screentones

Using screentones to represent different colors

Light pink

Blue

Red

Customarily, red and green nails are spotted black or represented with a graduated screentone, light pink and yellow nails are represented with a light screentone in the #10 to #19 range, while blue nails are represented with a #42 or #52 screentone.

Toenails

Neatly clipped

Front view

View from above

Eyes, Eyelids, and Eyelashes

The Structure of the Eye

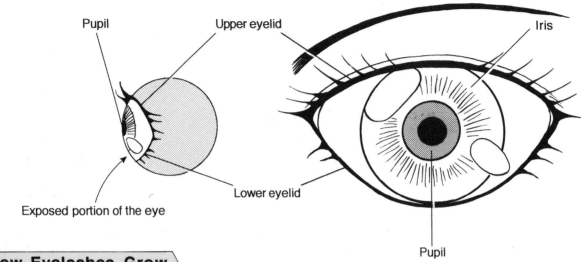

Pupil

Upper eyelid

Iris

Exposed portion of the eye

Lower eyelid

Pupil

How Eyelashes Grow

A Selection of Eyelids with Folds

Simple

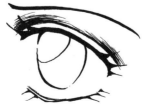

Heavy

Contoured

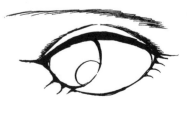

Realistic

Slanted eyes are slanted even when viewed from the side

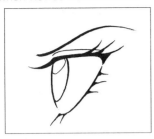

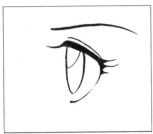

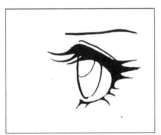

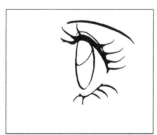

Slanted eyes with thin eyelashes

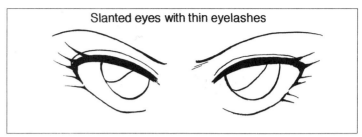

Ordinary eyes with ordinary eyelashes

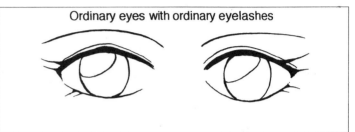

Ordinary eyes with thick eyelashes

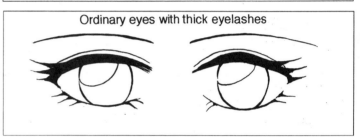

Heavily made-up eyes with four-way false eyelashes

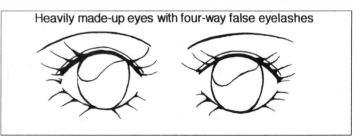

Eyelashes from Different Angles

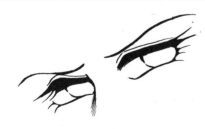

81

Different Types of Eyes

	Realistic Eyes	Wide Eyes	Manga Eyes = Tall Eyes
Open			
Half-closed			
Closed			
Closed tightly			
Smiling			
Looking sideways			
Winking			

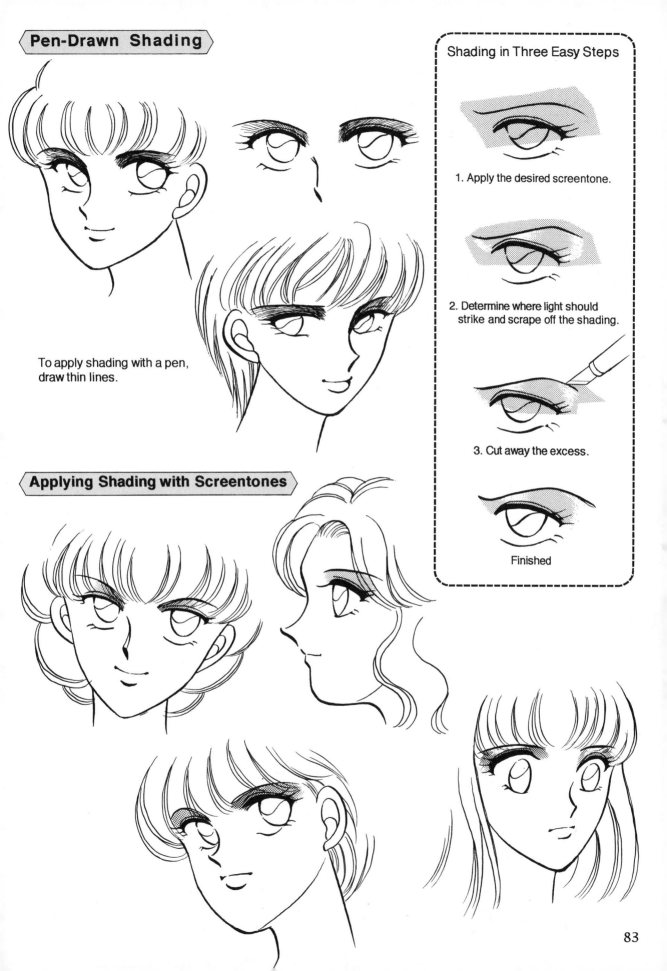

Pen-Drawn Shading

To apply shading with a pen, draw thin lines.

Applying Shading with Screentones

Shading in Three Easy Steps

1. Apply the desired screentone.

2. Determine where light should strike and scrape off the shading.

3. Cut away the excess.

Finished

83

The Mouth and Lips

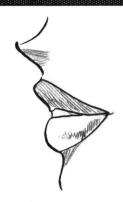

You can achieve many different
effects with the mouth according
to what aspect you choose to highlight.

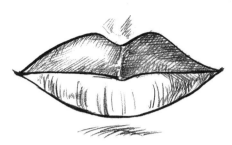

Special Effects

When seeking a particular effect
with the mouth, focus attention on it
by cropping the frame to exclude the eyes.

84

Effects You Can Achieve with Black and Shading

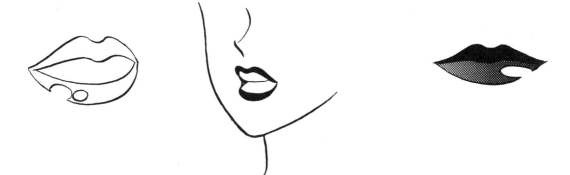

Solid black plus hatching

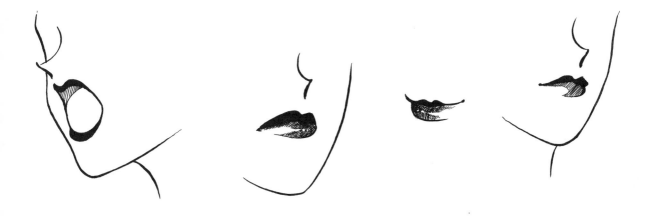

Solid black plus screentones

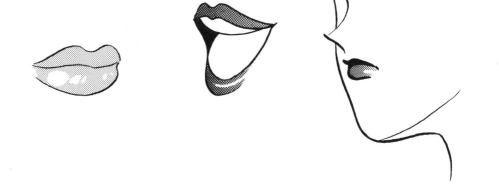

The Ears and Earrings

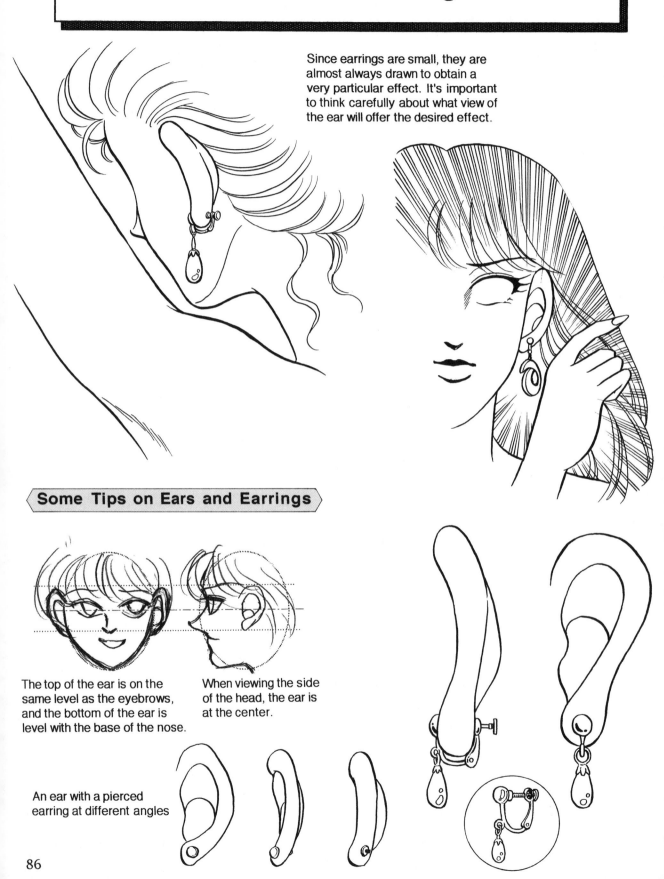

Since earrings are small, they are almost always drawn to obtain a very particular effect. It's important to think carefully about what view of the ear will offer the desired effect.

Some Tips on Ears and Earrings

The top of the ear is on the same level as the eyebrows, and the bottom of the ear is level with the base of the nose.

When viewing the side of the head, the ear is at the center.

An ear with a pierced earring at different angles

The Hair

Hair styles are determined primarily by two characteristics: how stiff the hair is, and how much of it there is.

The Difference Between Coarse Hair and Fine Hair

If the hair is fine and soft, it tends to lie flat against the scalp.

If the hair is coarse and stiff, it tends to grow outward from the scalp.

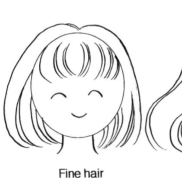

Fine hair

Coarse hair

Typical hair styles

Hair Density

Fine and thin

Fine and dense

Coarse and thin

Coarse and full headed / dense

Coloring the Hair

Outline only

Solid black

Graduated screentones, scraped

Pen work only

Black with white highlights

Layered screentones

Pen work and screentones

Black with white highlights

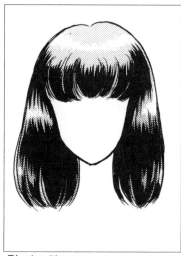

Black with scraped screentones

Tips for Drawing Hair

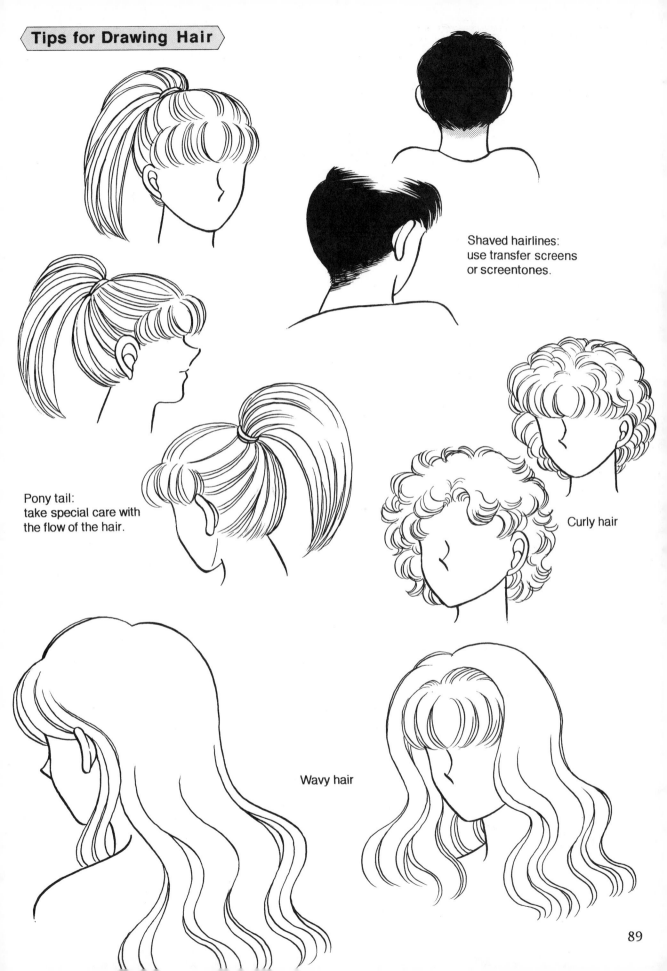

Shaved hairlines:
use transfer screens
or screentones.

Pony tail:
take special care with
the flow of the hair.

Curly hair

Wavy hair

A Catalogue of Undergarments

1. Underpants

T-thongs	High-cut	Ordinary

String panties	Girdle

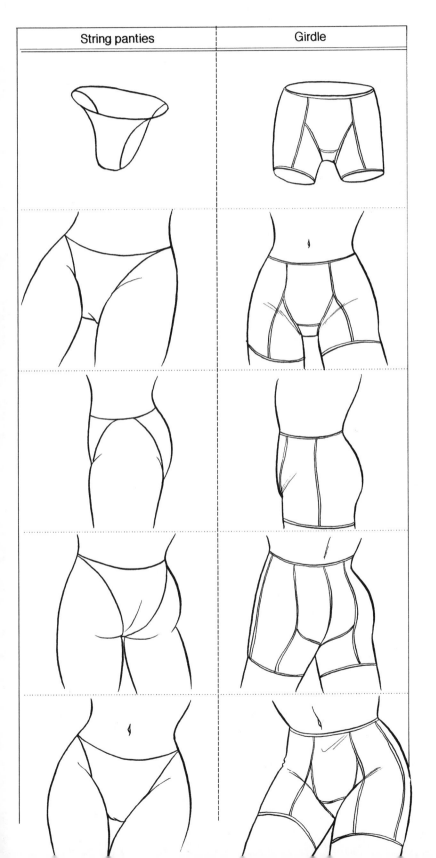

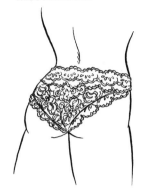

Ordinary with lace on back

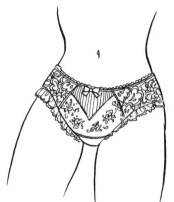

Ordinary with lace throughout

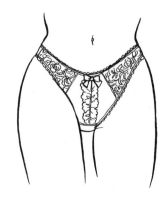

High-cut with lace throughout

91

Ordinary: With lace	Ordinary: Plain

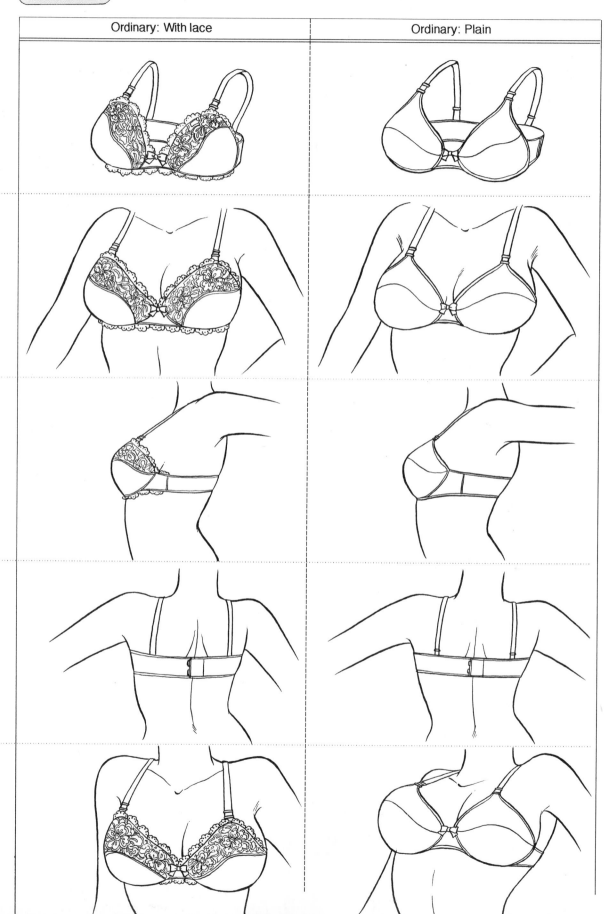

Sporty

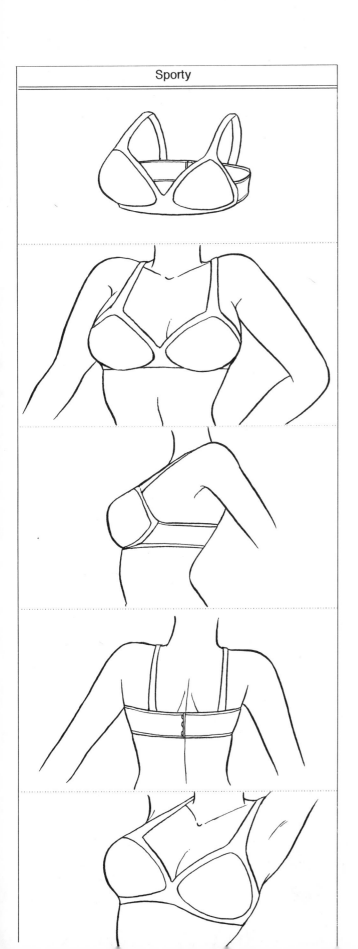

Miscellaneous

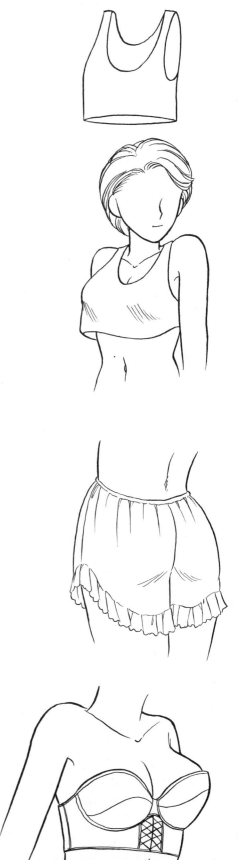

93

3. Other Items

Body suit

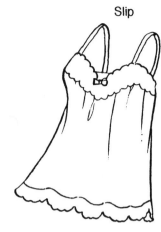

Slip

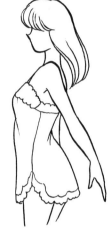

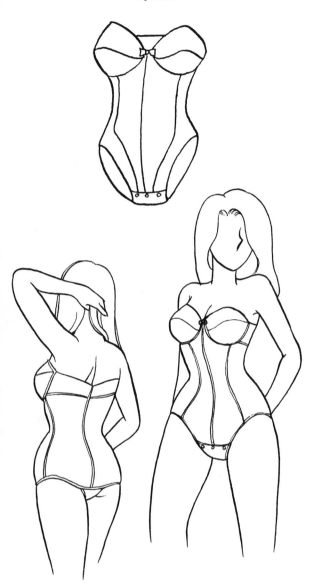

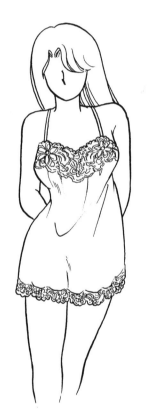

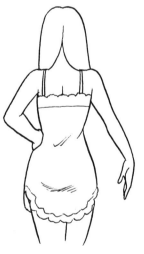

Variation

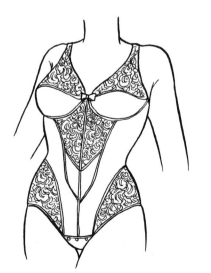

Laced slip variations

Underpants: The Different Look of Different Fabrics

When not being worn

Silk

Light weight puckering fabric

Standard weight cotton-synthetic mix

Silk
- Hugs body curves faithfully.
- Wrinkles appear as very delicate lines.

Light weight puckering fabric
- Draw wrinkles along the top and bottom hems.
- A few wrinkles follow the contours at the crotch
 and hips.

Standard weight cotton-synthetic mix
- Draw only the outline and seams of the panties.
- A plain look, with the feeling that the panties hug
 the contours of the body.

What are the secrets to drawing faces in profile?

Answer

Based strictly on bone structure, it is strange for the eyes to be set too far back from the nose, but in drawings, such a style may still be perfectly acceptable. There are many different ways in which the eyes, nose, and mouth can be distorted or exaggerated to good effect, so you can develop your own style without being too worried about actual bone structure.

In Egyptian drawing style, the face is presented in profile, but the eye gazes straight out at the viewer.

Outline of the head: even the mouth protrudes quite a bit.

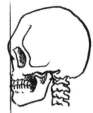

Bone structure: the face is nearly flat.

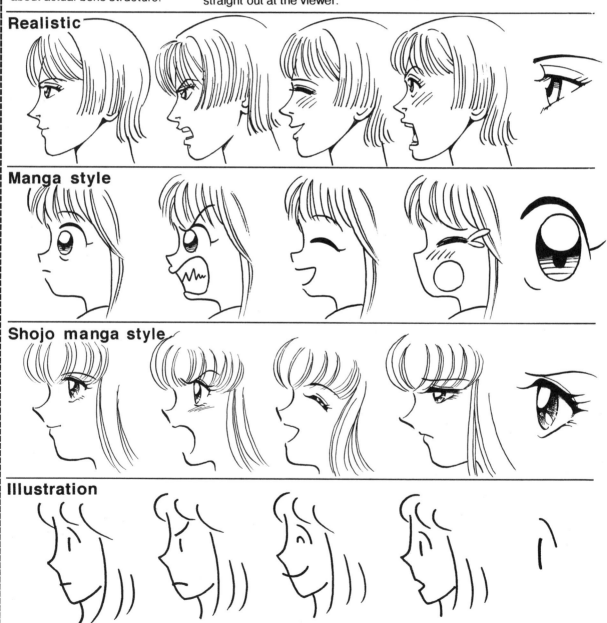

Realistic

Manga style

Shojo manga style

Illustration

The Female Figure Goes to School

1. Getting Dressed: The Blouse

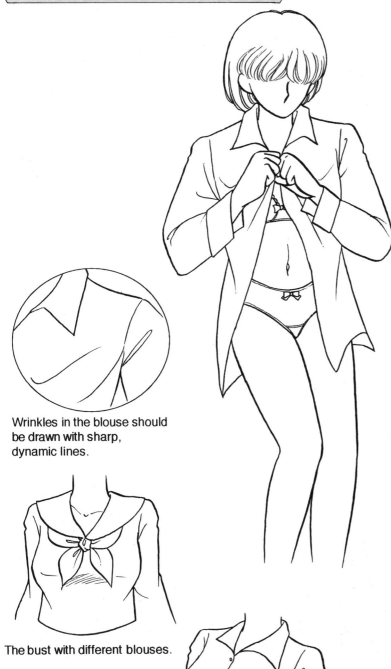

Use screentones to draw
bra showing through blouse.

Wrinkles in the blouse should
be drawn with sharp,
dynamic lines.

The bust with different blouses.

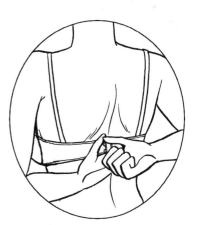

Fastening the bra

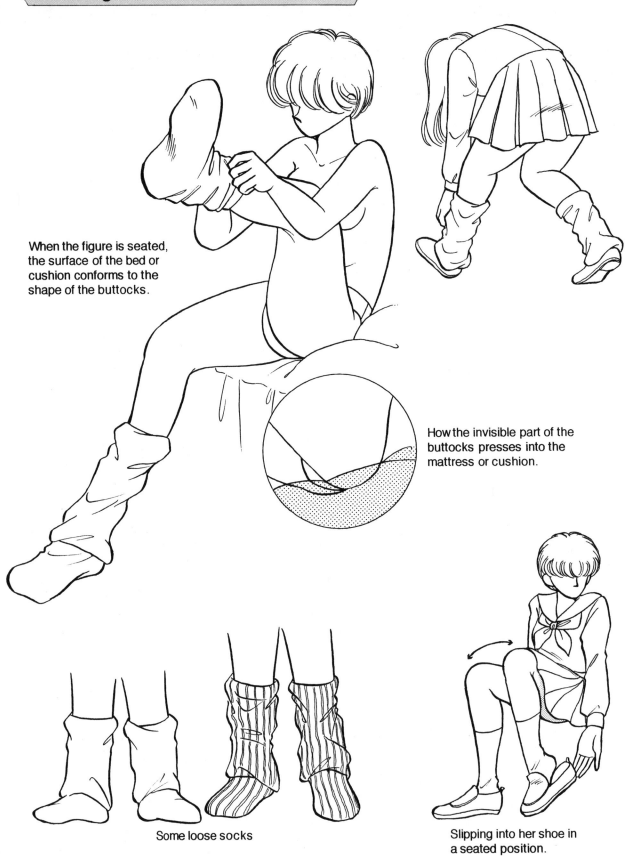

When the figure is seated, the surface of the bed or cushion conforms to the shape of the buttocks.

How the invisible part of the buttocks presses into the mattress or cushion.

Some loose socks

Slipping into her shoe in a seated position.

Even when the character is simply standing or sitting straight, avoid making the figure completely rigid.

Supple figure, standing Rigid figure, standing

Supple figure, seated Rigid figure, seated

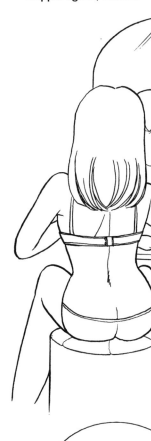

Lips and lipstick

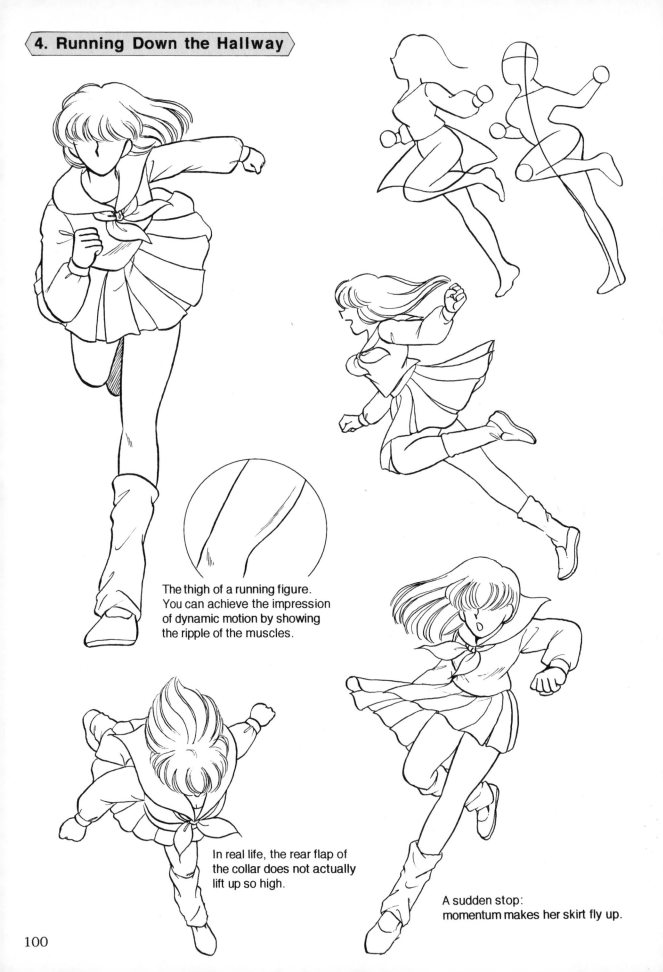

The thigh of a running figure. You can achieve the impression of dynamic motion by showing the ripple of the muscles.

In real life, the rear flap of the collar does not actually lift up so high.

A sudden stop: momentum makes her skirt fly up.

5. Sitting on a Chair

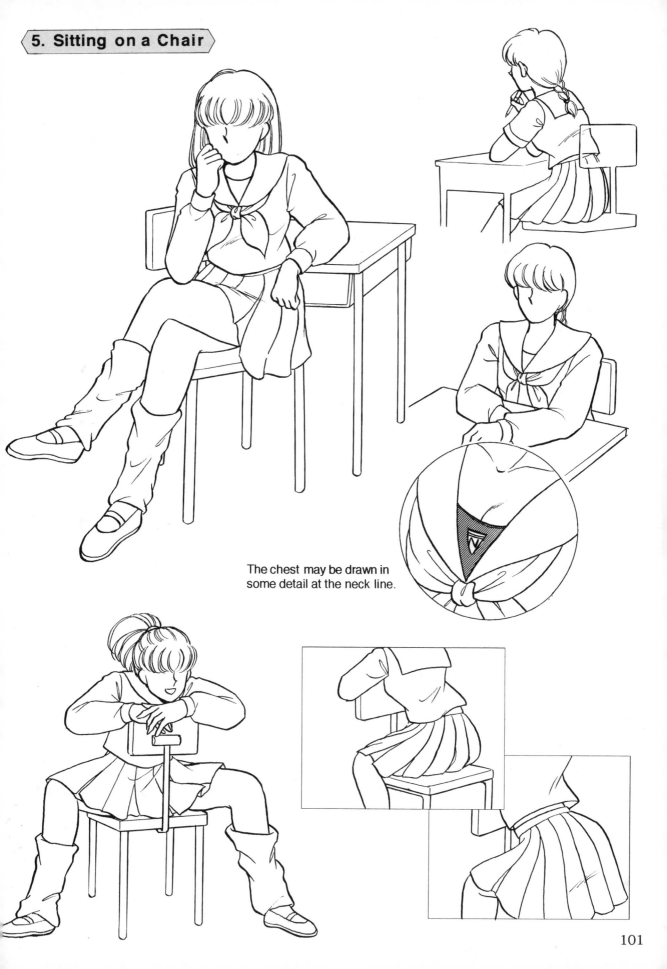

The chest may be drawn in some detail at the neck line.

6. Jumping up in Joy: In School Uniform

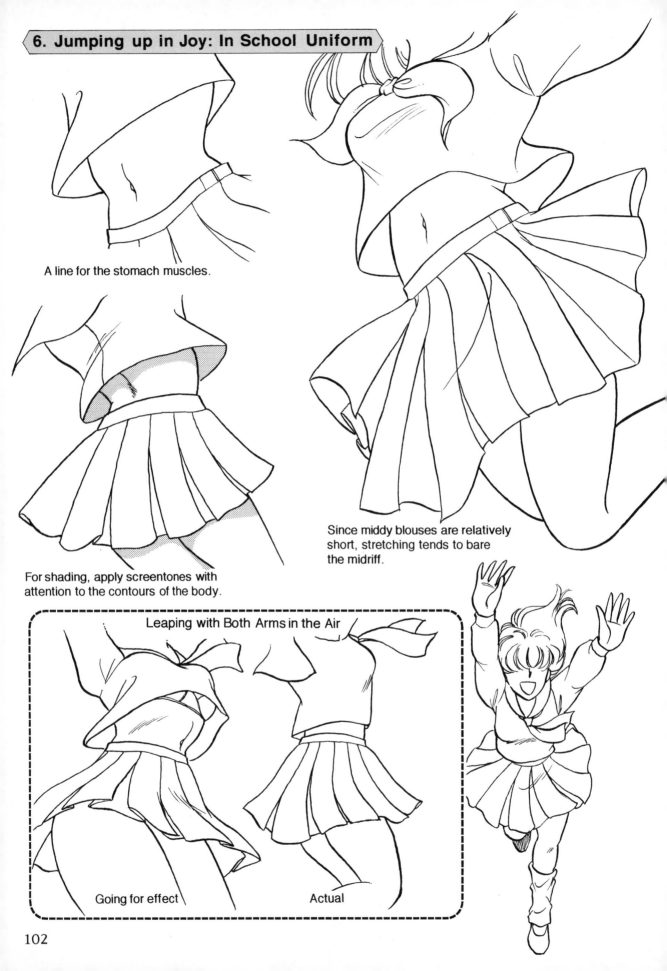

A line for the stomach muscles.

For shading, apply screentones with attention to the contours of the body.

Since middy blouses are relatively short, stretching tends to bare the midriff.

Leaping with Both Arms in the Air

Going for effect

Actual

Bunched up gym clothes should be drawn with soft, gentle lines to reflect the softness of the fabric.

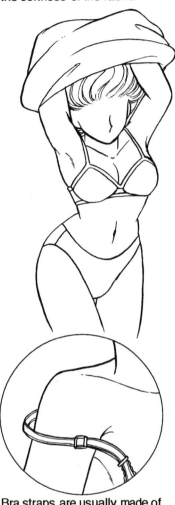

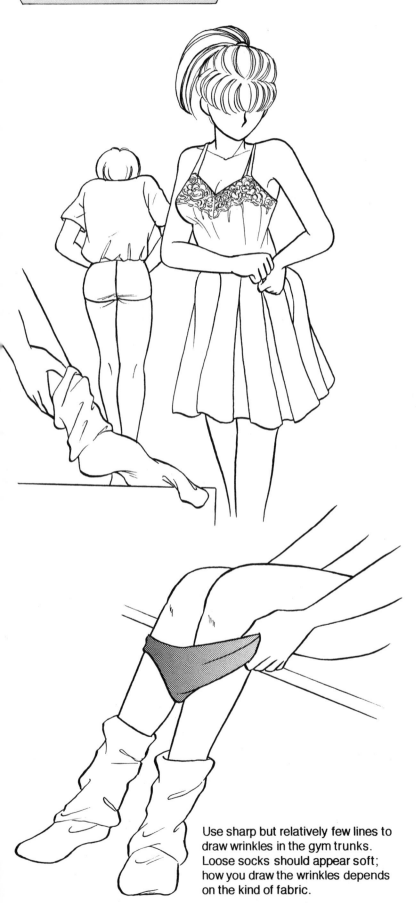

Bra straps are usually made of sturdy material.

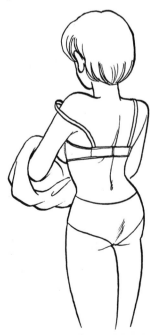

Use sharp but relatively few lines to draw wrinkles in the gym trunks. Loose socks should appear soft; how you draw the wrinkles depends on the kind of fabric.

With jersey hanging loose

With jersey tucked-in

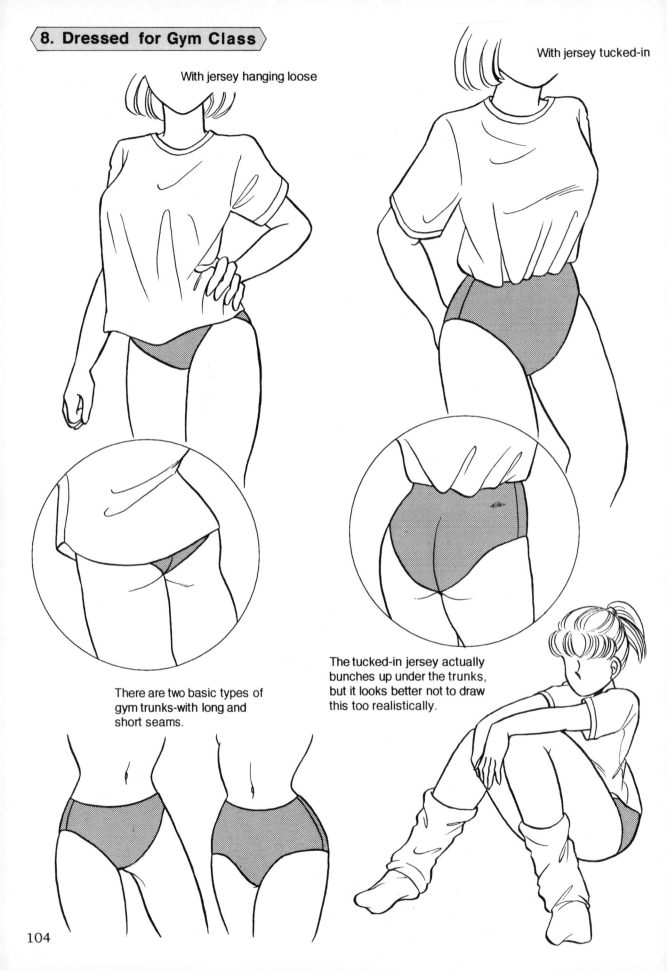

There are two basic types of gym trunks-with long and short seams.

The tucked-in jersey actually bunches up under the trunks, but it looks better not to draw this too realistically.

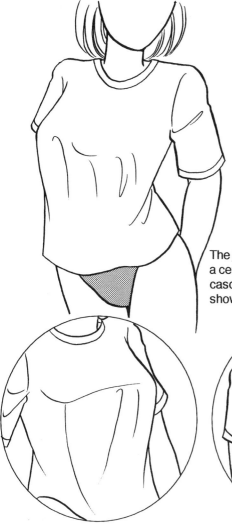

The jersey is smooth, but also has a certain weight. A series of wrinkles cascading from the breast line shows the thrust of the bust.

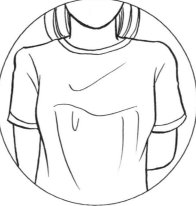

Wrinkles on the back typically appear around the shoulder blades and the waist.

The lower abdomen: You can use black and graduated screentones to achieve a sense of dimension.

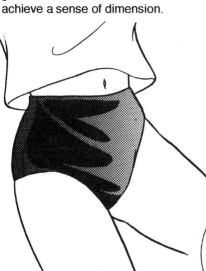

Black, with the lines of the buttocks shown in white. The way the buttocks appear to bulge out beneath the seams creates a realistic effect.

It is best not to draw too many wrinkles in the crotch.

Using transfer screens to show reflected light can give the buttocks of the trunks a feeling of volume.

105

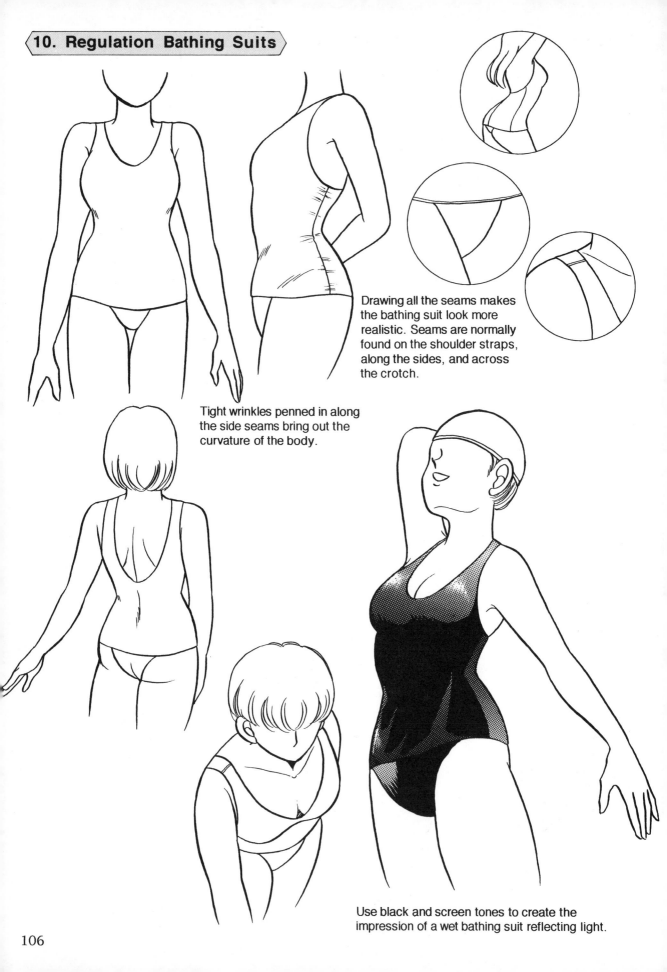

Drawing all the seams makes the bathing suit look more realistic. Seams are normally found on the shoulder straps, along the sides, and across the crotch.

Tight wrinkles penned in along the side seams bring out the curvature of the body.

Use black and screen tones to create the impression of a wet bathing suit reflecting light.

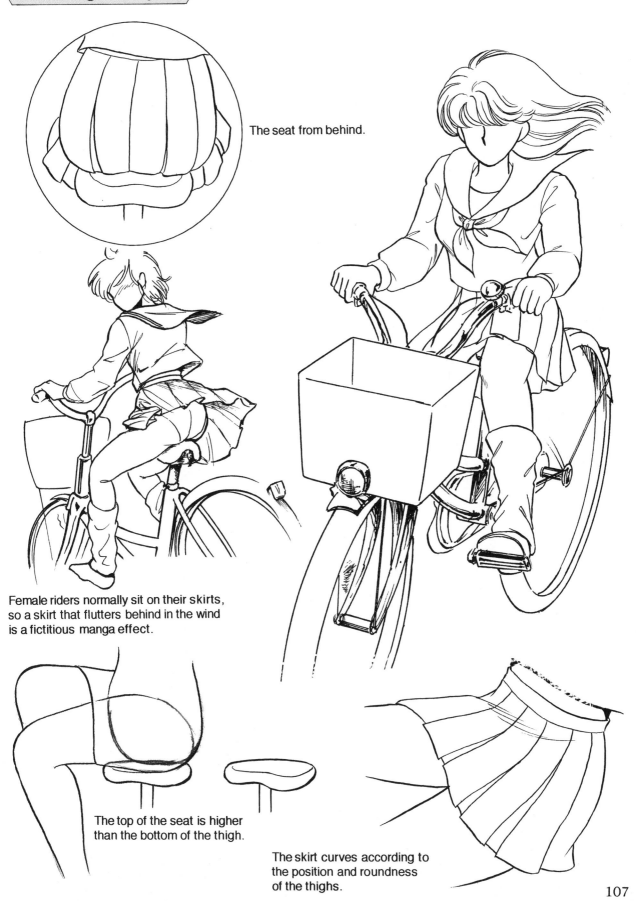

The seat from behind.

Female riders normally sit on their skirts, so a skirt that flutters behind in the wind is a fictitious manga effect.

The top of the seat is higher than the bottom of the thigh.

The skirt curves according to the position and roundness of the thighs.

12. On the Way Home: Walking Outdoors

Distinctions should be made between summer and winter uniforms. The summer fabric is light and shows more wrinkles, while the winter blouse should be drawn without many wrinkles.

In a gentle wind

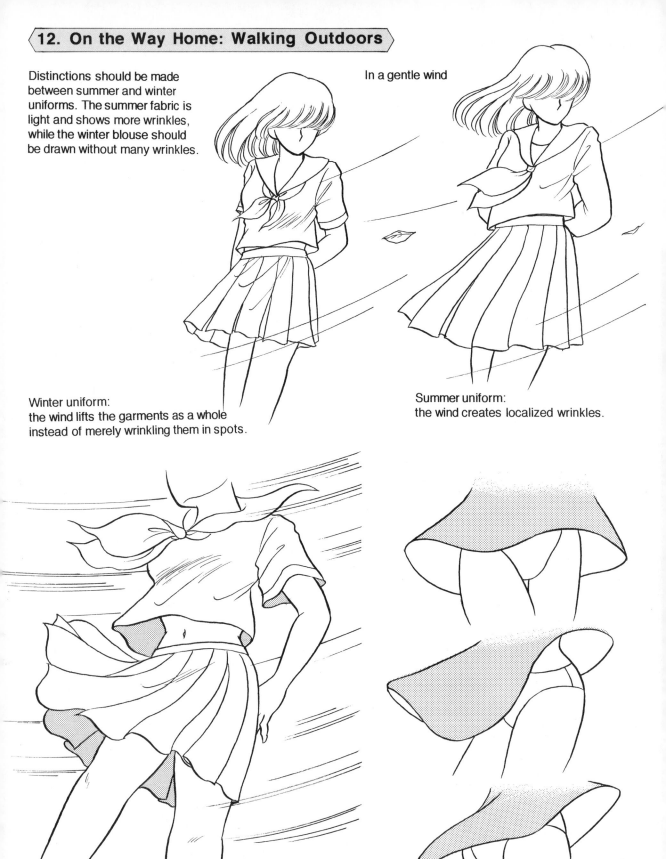

Winter uniform:
the wind lifts the garments as a whole instead of merely wrinkling them in spots.

Summer uniform:
the wind creates localized wrinkles.

When showing a strong gust, summer and winter uniforms should both be drawn flapping in the wind.

When a skirt gets blown up in the wind, the arc of the hem shows the weight of the fabric.

Chapter 4
Learn from the Pros

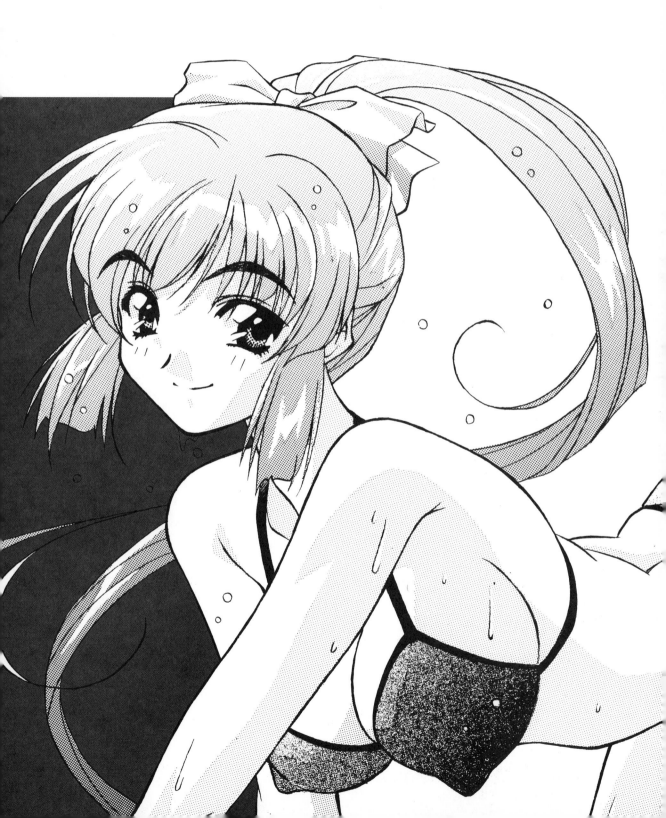

Girl in Middy Uniform

Drawn by Masaru Kaku

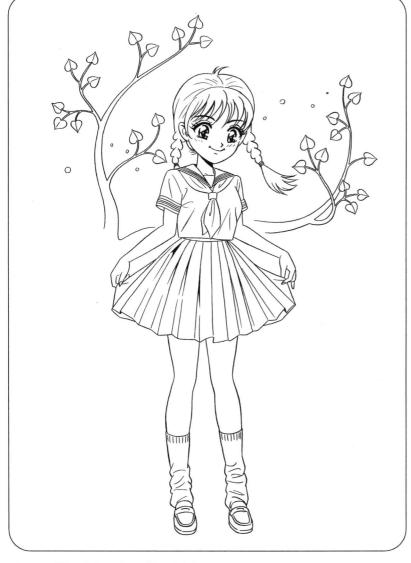

Adding some black accents when drawing the pleats brings a feeling of dynamic dimension to a skirt that would otherwise appear flat and dull.

Line drawing

Narrow Shoulders for a Youthful Effect

◆ Narrow shoulders and a trim figure offer the image of a cute young teenager. Since narrow shoulders make the head look larger, it typically leads to a childish look. But give her some curves and long, shapely legs, and she becomes a vivacious teenager.

◆ A waist narrower than her shoulders and the lines that show her breasts swelling against her blouse let us see her shapely figure even through her clothes. Also, the lines of her thighs suggest the well-rounded buttocks from which they grow.

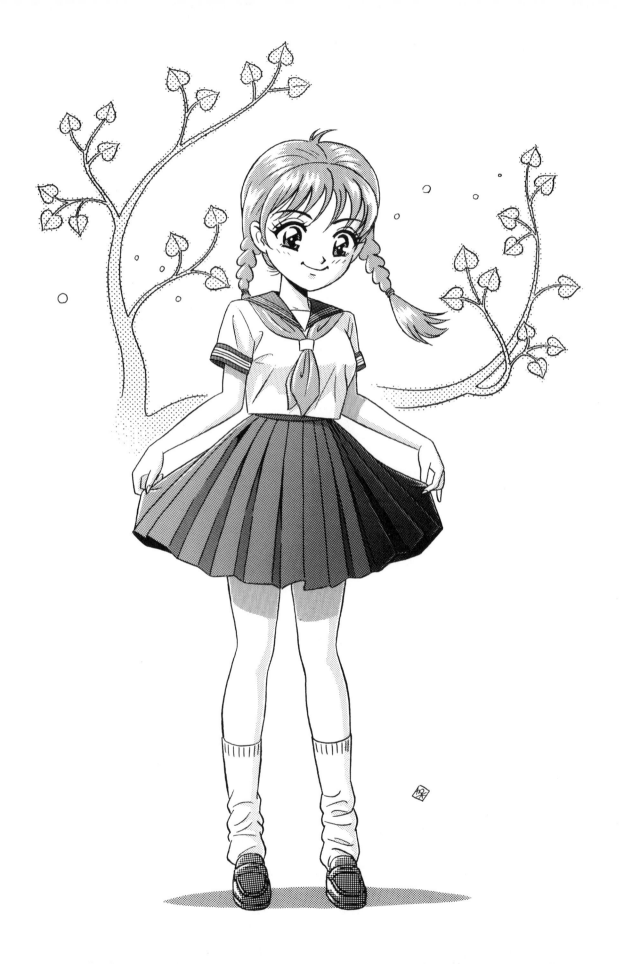

Beauty with Bouquet

Drawn by Jun Matsubara

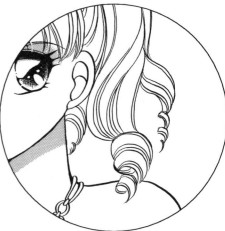

Curled hair is a hallmark of girls comics (shojo manga). Here, a dozen or so lines twist together to form each tress, and you can see how the delicately curving lines and the varying widths of white space between them combine to give the curls a remarkable feeling of volume.

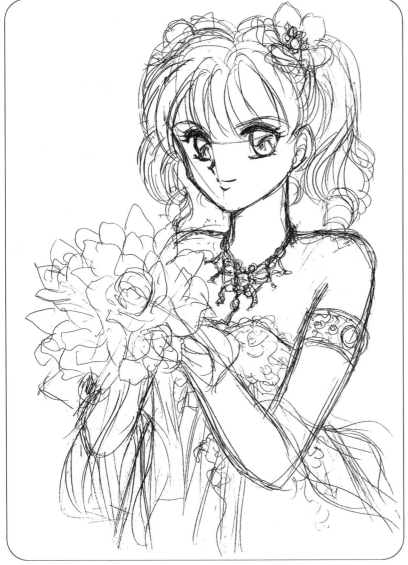

Rough sketch

Preserve Your Original Conception through Attention to Detail

◆ Start by blocking out the overall image, and then work up a complete rough sketch. If you go ahead and rough in the flowers and other accessories at this stage, you should be able to proceed with confidence and finish with a drawing that remains quite faithful to your original conception.

◆ When you pick up your pen to complete a rough sketch like this, you must have a clear vision of the final drawing you wish to create, and your pen must be controlled by a very precise sense of where each line must go.

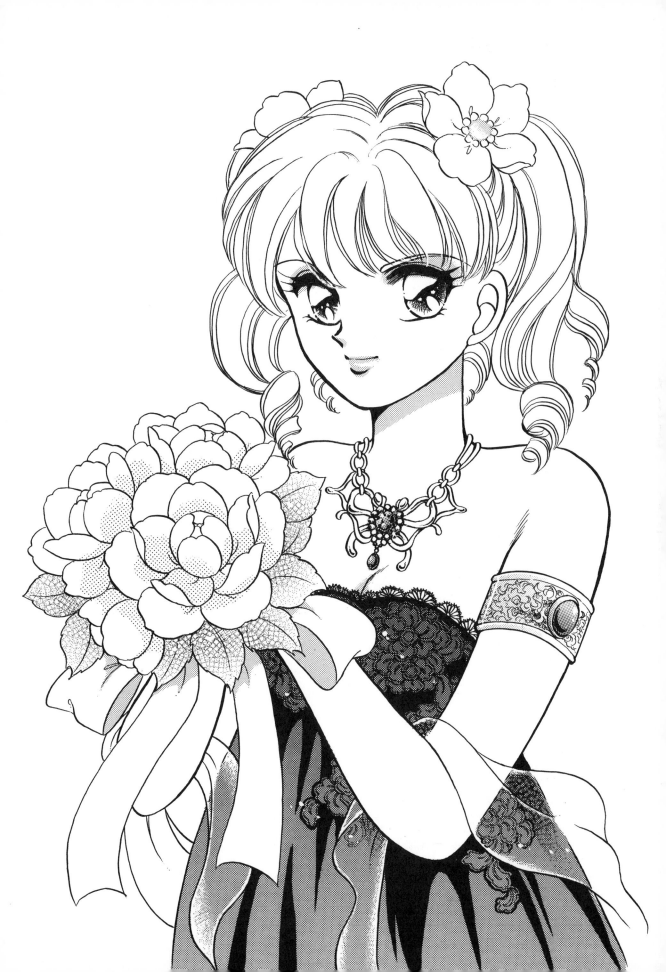

Alluring Adult

Drawn by Yasuo Matsumoto

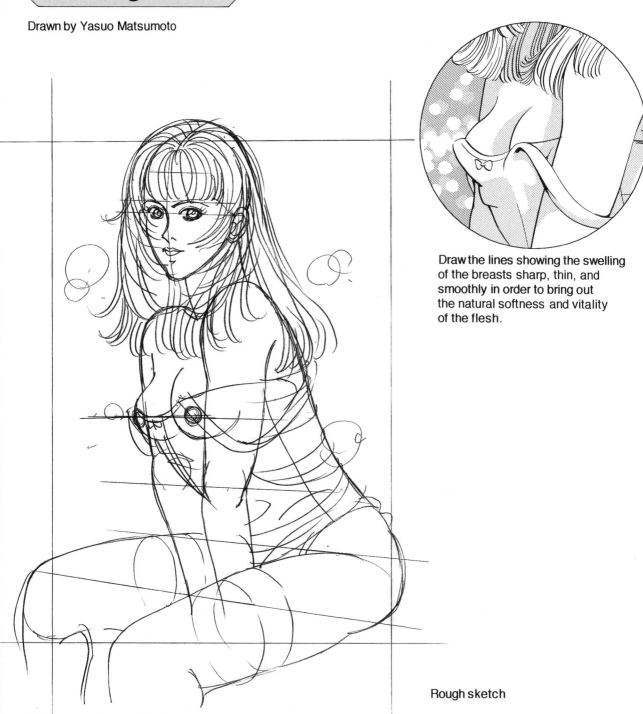

Draw the lines showing the swelling of the breasts sharp, thin, and smoothly in order to bring out the natural softness and vitality of the flesh.

Rough sketch

Achieving a Natural Balance

◆ When deciding on the figure's composition and overall proportions, use your guide lines to maintain the proper balance. Focusing too much on the proportions can often result in a lifeless figure, but the drawing will come alive like this so long as you develop the composition with a clear visual image.

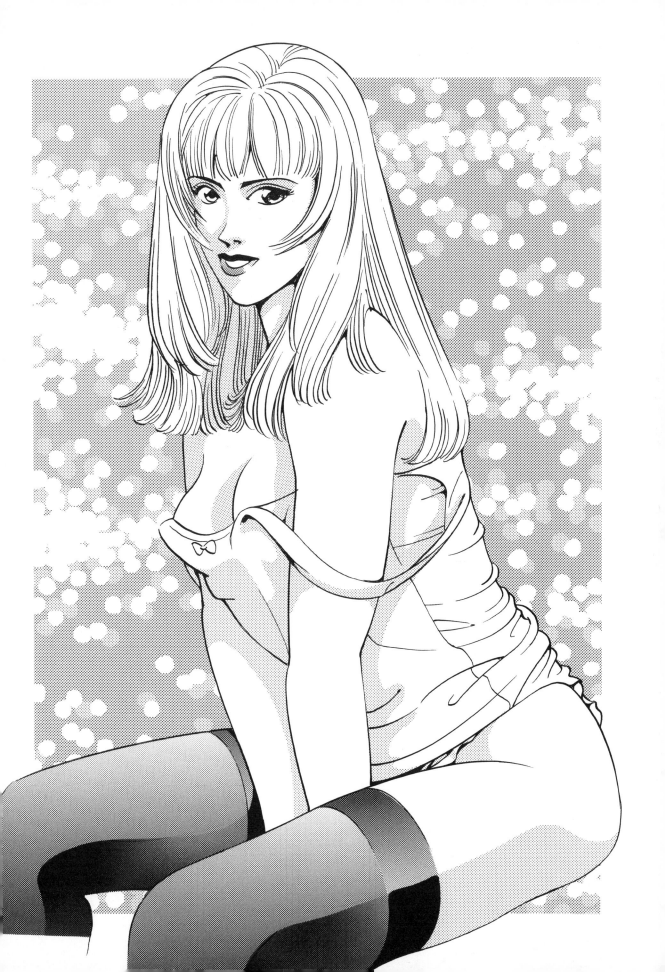

Dream Fantasy

Drawn by Morio Harada

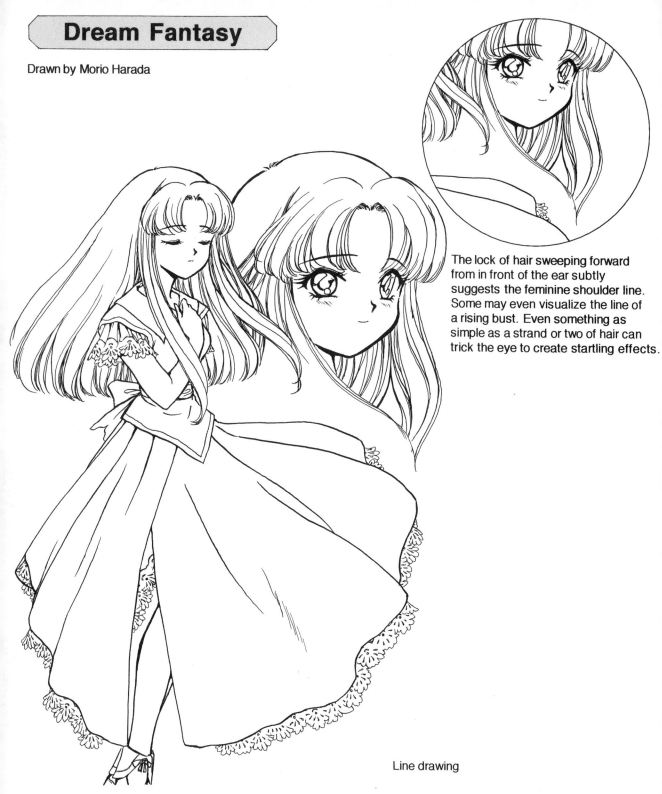

The lock of hair sweeping forward from in front of the ear subtly suggests the feminine shoulder line. Some may even visualize the line of a rising bust. Even something as simple as a strand or two of hair can trick the eye to create startling effects.

Line drawing

Your Most Cherished Dreams are the Soul of Manga

◆ Even in this simple line drawing, the artist has meticulously detailed the lace at the sleeve and around the hem. But the drawing takes on a whole new vibrancy with the addition of a black bodice and an elegant skirt border created with screentones. The black ribbon at the ankle provides another elegant accent.

◆ The finished drawing seems too real to be a dream, yet too imaginary to be real, and perhaps in that we can see the very essence of manga.

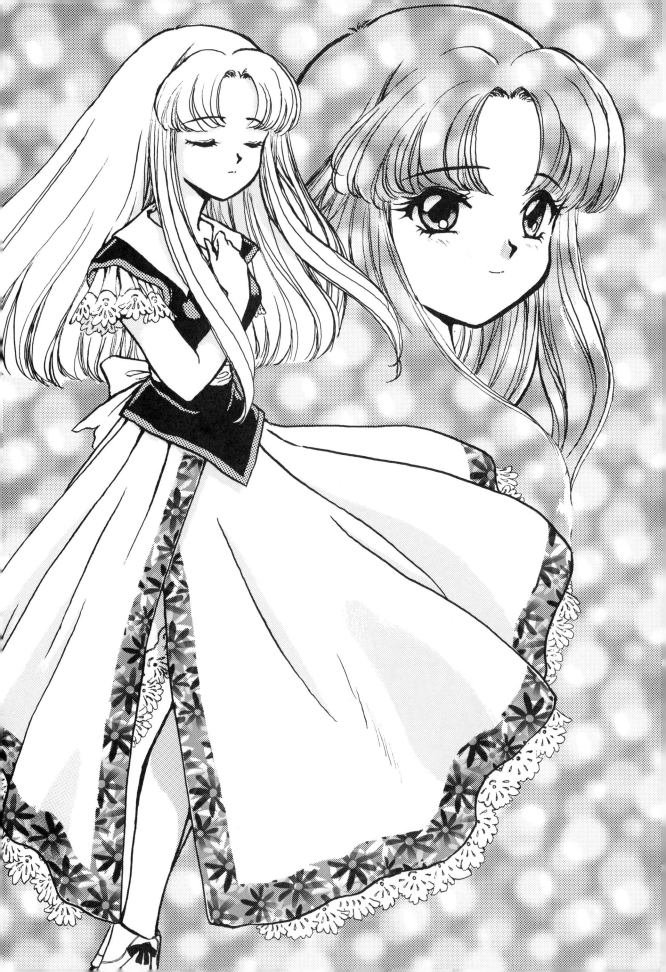

Drawn by Bancho Hoshino

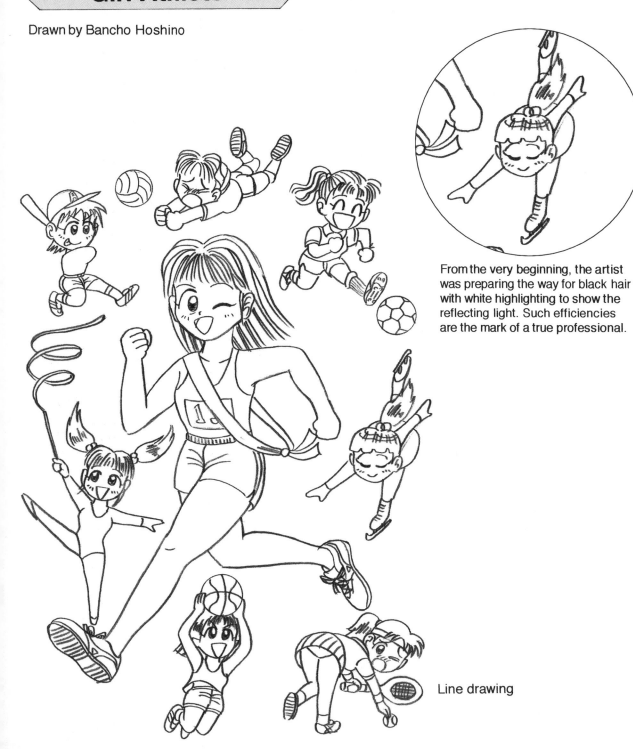

From the very beginning, the artist was preparing the way for black hair with white highlighting to show the reflecting light. Such efficiencies are the mark of a true professional.

Line drawing

A Medley of Cheerful Faces for a Drawing Bursting with Fun

◆ It takes time to draw an initial sketch that is close to finished quality, but the advantage is that it simplifies your final pen work. When the pen work can move swiftly, it energizes the characters and lends spontaneousness to their expressions.

◆ A template was used to draw the circle for the ball, and careful attention to details such as shoe strings and soles, even with simplification, helps give the drawing a feeling of balance.

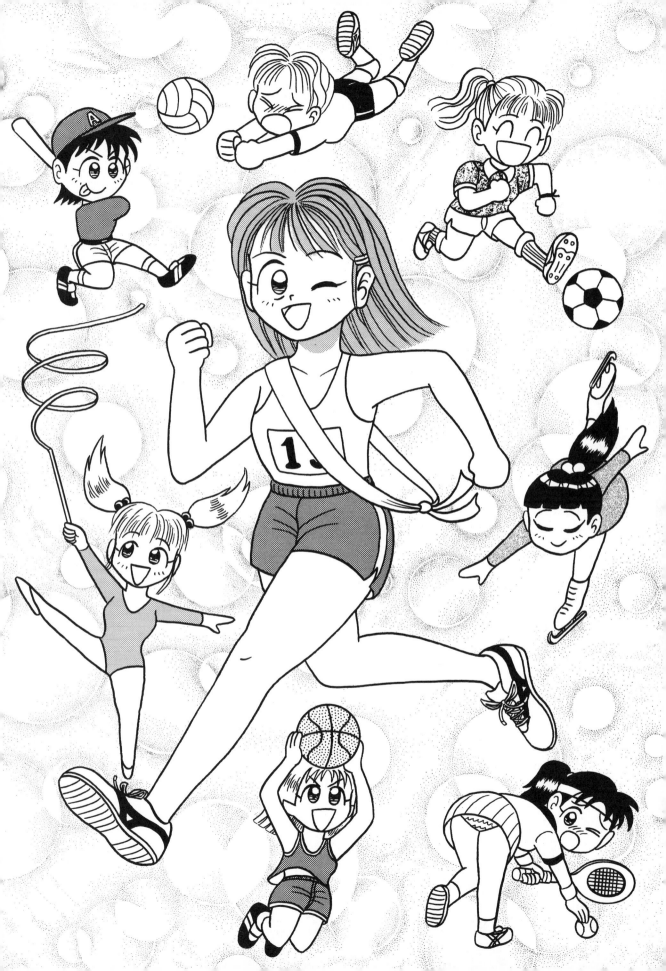

Sexy Babe

Drawn by Ganma Suzuki

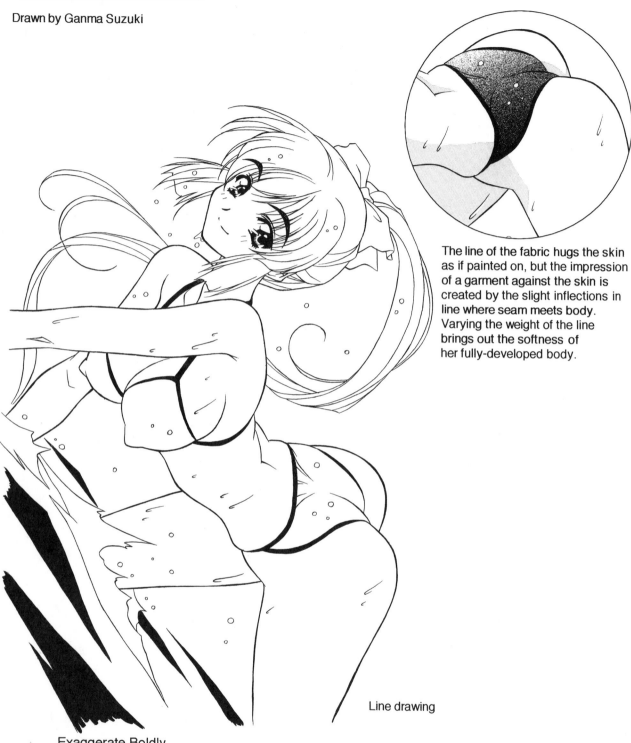

The line of the fabric hugs the skin as if painted on, but the impression of a garment against the skin is created by the slight inflections in line where seam meets body. Varying the weight of the line brings out the softness of her fully-developed body.

Line drawing

Exaggerate Boldly

◆ Draw the figure with large breasts and buttocks to create a well-endowed woman full of vim and vigor. The eye-popping voluptuousness of the body is counterbalanced by a cute, slender neck and a slightly longer than normal torso, and the serene expression on her face adds to an impression of freshness and inviting softness. In poses that feature the buttocks, it's often easy to get excessively caught up in the shape of the two cheeks, but always keep in mind as you draw that the buttocks are where the legs grow from.

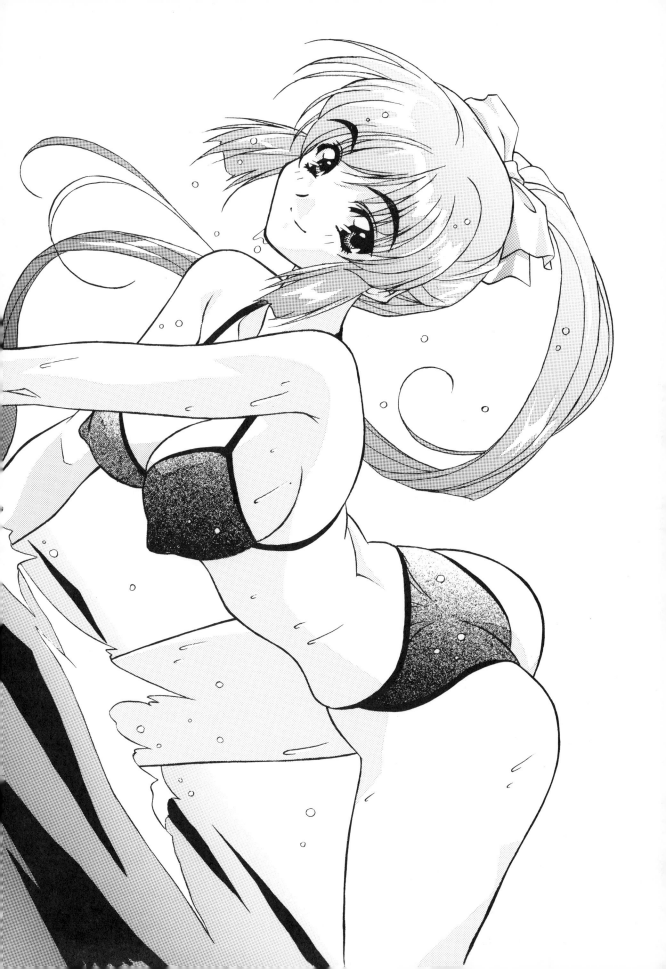

Humorous Illustration

Drawn by Shoko Ando

Even lines that look simple and artless can show movement and space. Draw as if you have become the object you are drawing, rather than as a person looking at it from the outside.

Rough sketch

Simplified Features, but Drawn with Warmth

◆ The facial features have been simplified to an extreme, and the body is distinctly stylized. But by applying the same style to each character, a certain feeling of rhythm is born between them. The unadorned dots and lines actually reveal a remarkable amount of expression. When drawn with a clear image and distinct sense of mood, even the simplest figures can be filled with heart.

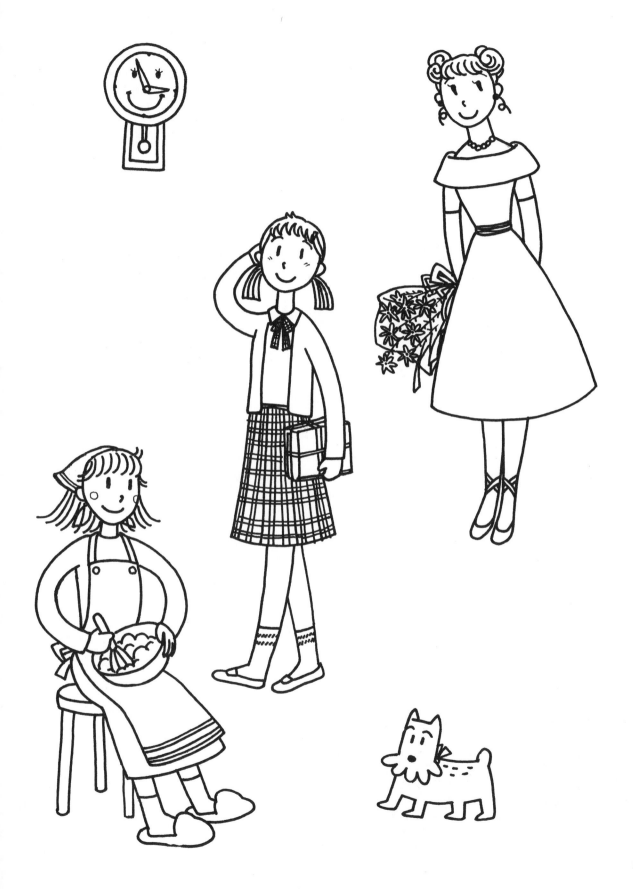

Coquettish Maiden

Drawing by Yu Manabe

The subtle structural detail seen in the relationship of the shoulder strap to the curve of the breast is one of the secrets of making the figure seem more real and tangible. Such effective use of detail can only come from one's native artistic sense.

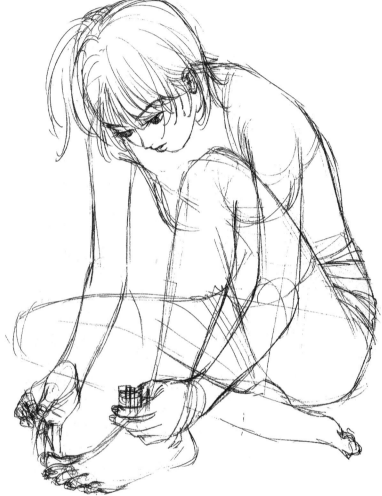

Rough sketch

For Proper Balance and Structure, Sketch Even What Won't Show

◆ By choosing a pose that provides a feeling of depth all by itself, you can create a powerful illusion of physical presence even in a standalone figure without any background. The secret to getting the right balance in this figure lies in including details of the loin area in the rough sketch, even though that part is slated to be spotted in black.

◆ The logo on the shorts provides an important accent. It may seem like a trivial thing, but drawing the logo neatly and sharply contributes to a feeling of tautness, and intensifies the feeling of physical presence.

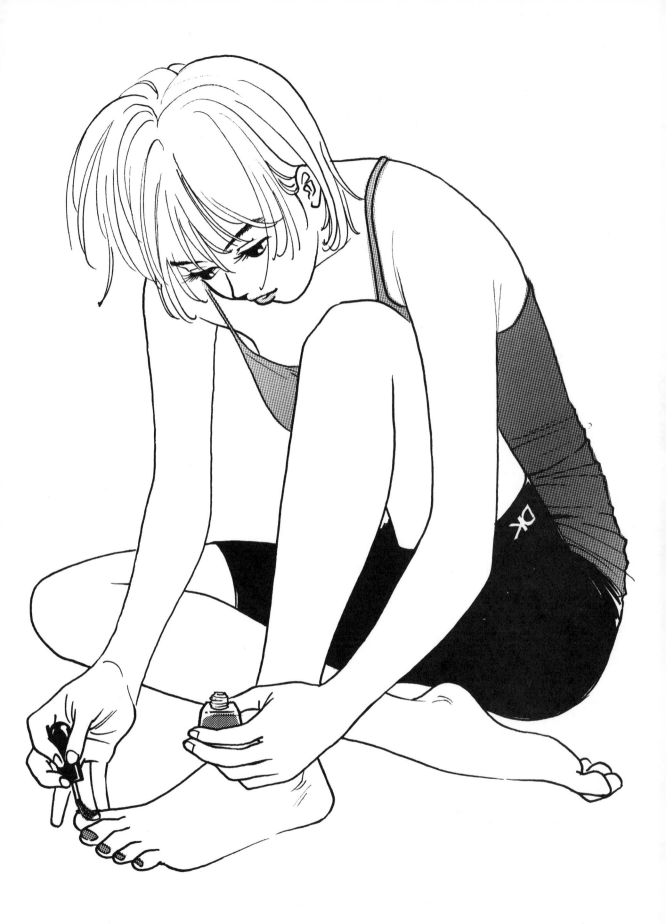

Glamourous Beauty

Drawing by Noriyoshi Inoue

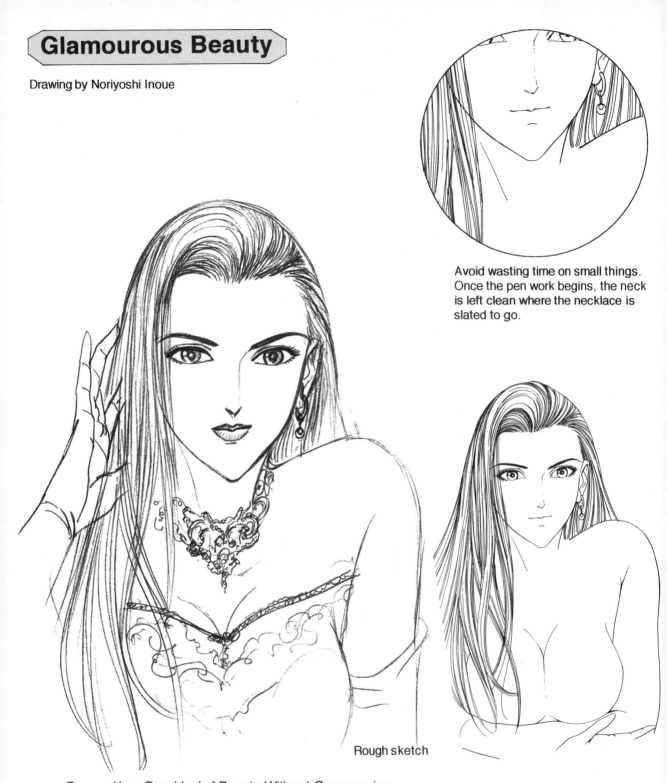

Avoid wasting time on small things. Once the pen work begins, the neck is left clean where the necklace is slated to go.

Rough sketch

Pursue Your Own Ideal of Beauty-Without Compromise

◆ On the way to a finished drawing, you have only so much time to decide on the composition, facial expression, accessories, and any special motifs you wish to include. In this case, the hand drawn so prominently in the rough sketch ultimately got removed. Since a significant amount of effort goes into even a rough sketch, the natural tendency would be to keep the hand even in the final pen work, but there is a valuable lesson in this example. In order to achieve the best possible rendering of your vision, you must sometimes be willing to change course, even if it means additional work. It is the refusal ever to compromise your vision that will ultimately bear the finest results.

126

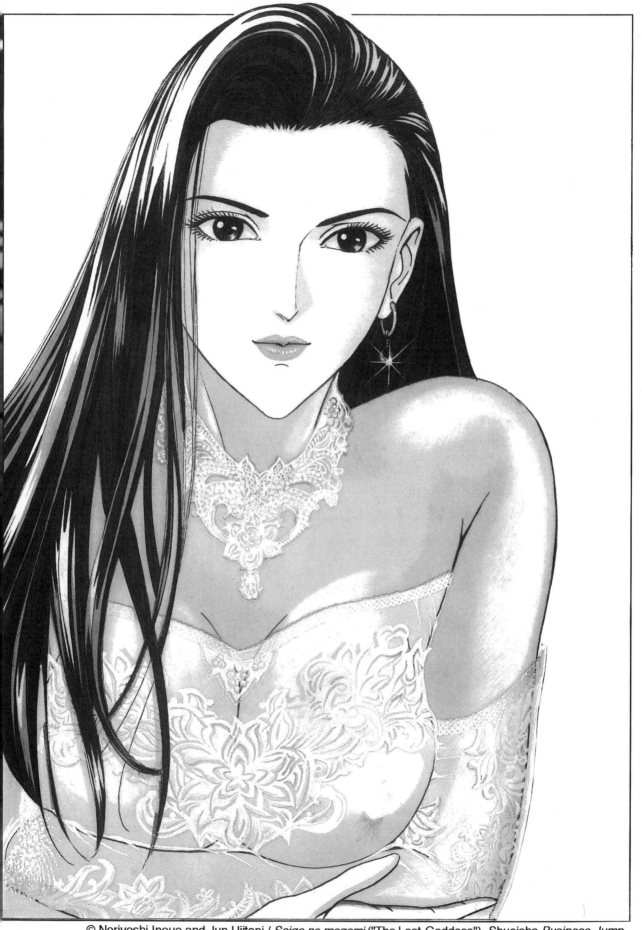

© Noriyoshi Inoue and Jun Ujitani / *Saigo no megami* ("The Last Goddess"), Shueisha *Business Jump*.